TRAVEL HEALTHY

Other Books by Lalitha Thomas

10 Essential Herbs

10 Essential Foods

Everywoman's Book of Common Wisdom
(with Erica Jen and Regina Sara Ryan)

TRAVEL HEALTHY

The Smart Traveler's Guide
to Staying Well Anywhere

Lalitha Thomas

HOHM PRESS
Prescott, Arizona

Cover design: Kim Johansen
Layout and design: Visual Perspectives

Library of Congress Cataloging-in-Publication Data

Thomas, Lalitha.
Travel healthy: the smart traveler's guide to staying well anywhere / Lalitha Thomas.
p. cm.
Includes bibliographical references and index.
ISBN 1-890772-25-9 (pbk.: alk. paper)
1. Travel—Health aspects. 2. Naturopathy. I. Title.
RA783.5 .T467 2002
616.6'8—dc21
2002012486

HOHM PRESS
P.O. Box 2501
Prescott, AZ 86302
800-381-2700
http://www.hohmpress.com

This book was printed in the U.S.A. on acid-free paper using soy ink.

06 05 04 03 02 5 4 3 2 1

CONTENTS

Introduction — vii

Chapter 1. The Smart Traveler's Health Kit — 1

Chapter 2. Hydration is Life — 40

Chapter 3. Healthy Foods Everywhere — 52

Chapter 4. Superfoods — 76

Chapter 5. Four Incomparable Travel Tonics — 87

Chapter 6. Exercise is Key — 110

Chapter 7. Beating Jet Lag — 113

Chapter 8. Pre-Trip Health Plan — 123

Chapter 9. Post-Trip Reentry — 127

Chapter 10. Travel Gadgets — 129

Chapter 11. Surfing the Net for Healthy Travel — 136

Chapter 12. Buyer's Guide — 142

Bibliography — 149

SYMPTOM-REMEDY INDEX — 158

INTRODUCTION

I could easily get very nervous about the possible threats to health and well being that travel and commuting can be. Just consider the details of my recent business trip. I sat on the airplane amidst mostly sick people who hacked and wheezed their way along from one winter flu epidemic to another. The recycled air of the airplane treated me to an "aroma banquet" of my fellow passengers' airborne microbes, effluents and body odors. The airline stewards served a meal that looked tired and smelled questionable, and I noticed that several of them brought their own food or didn't eat at all. As I tried to transfer to my next flight, I discovered irate crowds everywhere due to weather-canceled flights, with no hotels available. While waiting in line for two hours for my turn at the ticket counter, I observed varied arguments and outright fights between other passengers and airline personnel. Hundreds of

people had to spend the night in the airport, as I did. I slept tucked under an airport bench in order to avoid being kicked and bumped by the crowds. When I finally arrived at my destination, and while conducting several meetings a day for a week, I was faced with the inevitable restaurant meals, which included lots of unfamiliar items of foreign cuisine. Somehow, during it all, I managed to cut my foot badly enough to need first aid.

With all these difficulties and setbacks, however, I had a great trip and arrived feeling strong and healthy, and even fresh and ready-to-go, unlike many of my fellow sojourners who were worn-out, irritable, and looked sickly. *Travel Healthy* will reveal my secrets, which I'm happy to share with anyone willing to listen.

I know a lot about keeping to a minimum the health-negative side effects of travel—such as jet lag (also see Chapter 7), the result of disrupted schedules, devitalized diet and congested travel environments like airports and airplanes. With my **Smart Traveler's Health Kit** (see Chapter 1), which I always carry, I can handle and often prevent any health concerns that arise on the road. I know how to feed myself luxuriously on health-promoting foods even while on the go, and still come home feeling happy and balanced, even if I occasionally overeat. I know how to help children through the physical distress and emotional discomforts that come with travel. Basically, I know how to take my exquisitely healthy lifestyle with me wherever I go, without being rigid about it.

The methods I suggest are non-toxic and without harmful side effects, easy to do, fast acting, and actually health enhancing and rejuvenating. The difference between how I feel during and after travel, either internationally or just to a meeting in the city, and how many of my friends look and feel from their travels and commuting, is clear in the following true story about my friend Beth.

Home from a two week "vacation," Beth came to see me right away, as I've developed a reputation for being a Court of Last Resorts. Slumping into a chair, she looked like she'd lost a battle with a dragon.

"I had lots of fun," she tried to assure me, "but I must have picked up some bug. I feel exhausted and terrible now." She didn't need to tell me *that*. It was obvious.

Beth went on: "I have a slight but nagging cough, my energy level is way down, and my body aches. For a few days I had a little diarrhea, which I think was from a rich dessert I ate (well, maybe it was my second and third helpings), but my traveling companion insisted that I might have an intestinal parasite or bacteria, or 'it could be anything!' and urged me to see a doctor who—no questions asked—gave me antibiotics. The side effects put my system off balance for days, and I had trouble digesting anything. It also caused my yeast infection to act up. Whether I travel for pleasure or for business, I always seem to end up like this."

Since I had heard this and similar stories many times before from Beth and others, I didn't hesitate to

humorously ask the hard questions at once. "You took antibiotics for ordinary diarrhea? Didn't you take my Traveler's Kit with you? Don't you remember the great diarrhea remedy?" And since I know several of her default travel habits I added, "I suspect your intake of caffeine, alcohol, junk food, and late nights has worn you out even more than the antibiotics."

"When I'm on vacation I want to do whatever I feel like doing," she sounded like her teenager then, and she caught herself. Beth hesitated. "I am beginning to think you are right," she finally chuckled with a slightly guilty grin. "Do you think it could have started on my way to the airport when I stopped for doughnuts and coffee in place of a light, healthy breakfast?"

"You are a tough case," I said smiling. "But I will accept the challenge of your travel-survival training. I know the realities of travel in contrast to the vacation fantasies we all have, and I have lots of recommendations for prevention and antidotes for the over-indulgences. You don't have to worry about living like an ascetic, either. My plans are for having fun as you stay healthy."

Travel Healthy is written for all the Beths out there, of any age—adults and kids alike, as every chapter contains one or more **Hints for Use with Children**. I want my readers to know about rejuvenating travel foods that can be found almost anywhere in the world. I will describe how to put together a compact Smart Traveler's Health Kit with enough mix-it-yourself ingredients to handle everything from upset

digestion to all sorts of infections, fevers, and cut toes. The **SYMPTOM-REMEDY INDEX** (see p. 158) will point you to one or more ways to handle dozens of health conditions. You will read scores of tricks and tips—including how to grow edible sprouts in your car to enhance your "power-salads," and how to equip yourself with the best travel snacks and travel gadgets I have found in my long research on the matter. I won't leave you wondering where to buy your supplies either. (Don't you just get frustrated when you are told a great idea and then don't have the complete information to implement it *right away*?) Between the **Buyer's Guide** and **Internet sites** (see Chapters 11-12) you won't have to hesitate. With the "true stories" included, you'll have no doubt about how easily these ideas can be applied.

Do you want to know how to never again be at the effect of the horrible air in airplanes and on other crowded public transportation? Or what to do if you come down with a sinus infection in L.A. or the back-country of Nepal? How about tricks for lessening or eliminating jet lag? Or how to exercise during a twenty-hour stint in an airplane or other cramped conveyance? Or where to find the health enhancing items you need when you get "there," wherever *there* is?

Travel Healthy has the answers to these questions and more, without supporting the usual compromises we often think we must make as we travel—the coffee or caffeine drinks to keep us awake, the junk food to keep us from feeling hungry or bored, the

alcohol or sleeping pills to put us to sleep, the indigestion aids, the skipped meals, the bad water, the lack of exercise, and so on. This travel guide is proactive for your well being. The only side effects to my suggestions will be more strength and stamina for whatever you need to do. In fact, you may actually arrive home in better shape, physically and mentally, than when you started; or at least you can break even, which is highly unusual in these days of high-stress travel and commuting.

This book is for travelers who aspire to step out of mediocrity where health is concerned. It is an invitation to leap forward into the fine art of healthy travel.

My Experience as a Healthy Traveler

My approach to maintaining vibrant health in travel evolves from a lifetime of experience as an herbalist and healer, together with the important lessons learned in my own extensive trips throughout the U.S., Europe, Mexico, Canada and India, both alone and with groups of children. In the last year alone, for instance, my work has taken me to Germany once and France twice. I've flown to Vancouver, BC from my home in Arizona, three times. I've driven to Los Angeles once, and just getting from my remote desert home to the airport is three hours each way, not to mention the hour-long one-way trip to get to town. My two previous books, *10 Essential Herbs* (Hohm Press, Prescott, Arizona, 1996) and *10 Essential Foods* (1999) detail my system of dynamic nutrition and healthcare. I highly

recommend these books to you before you set out on your next great travel adventure, as they will enhance everything in this book.

Ever since I was a child I have been insatiably curious about my body's processes. I like to experiment, always trying to get a little more energy here, a little less stress there, more digestive power and quicker recovery. As a result I've discovered healthy energy boosters, "fixer-uppers" to soothe the ill effects of dietary and emotional habits. I've mixed up simple tonics and elixirs for all sorts of needs, for myself and others, and consider myself a veteran in the department of "Superfoods"—those foods that are especially concentrated in a "small package" from Nature; power-packed with nutrition, including necessary vitamins, minerals, amino acids, and enzymes, along with rejuvenating phytochemicals and antioxidants. Two famous Superfoods include spirulina algae and honeybee pollen. You will read all about them in Chapter 4.

My experimenting is sometimes criticized by those who want to "go with the conventional flow" as they travel. But I don't support that approach. Even "fun" can take its toll on our health. I think that preparation is a sign of maturity and wisdom. Planning ahead for health preservation despite a late-night party, a weekend-long feast, weeks of trekking, or numerous high-stress business gatherings can eliminate or at least mitigate the hangovers, bouts of indigestion, exhaustion or frazzled nerves. As far as I'm concerned it is certainly worth the effort.

How to Use This Book

You might not want to do everything that I suggest, and you really don't need to. Choose one or two approaches that appeal to you most and start with those. Identify an area where you already know you need help—like digestion, or relief of constipation, or low energy. Anticipate some of the additional health challenges that your method of travel or your destination will provide. If jet lag will be a significant factor, prepare for that in advance by trying out one or more of the tonics mentioned in Chapter 5 and trying some of the tricks in the jet lag chapter, Chapter 7. If you are planning a trip where clean water and clean food will be hard to find, be sure to become familiar with the preventive remedies for food poisoning (see GSE description in Chapter 1) and digestive disturbances (see pp. 36-37). If your travel style will include lots of parties with alcohol and rich food, you can protect yourself, to some extent, from the ill effects of overindulgence by power-packing your nutrition before and after with the Superfoods listed in Chapter 4, and by using the hangover remedies and liver tonic (both in Chapter 5) before and after the party. (Did I emphasize the "before *and* after" part enough?) You get the idea.

Bon Voyage.

1.

THE SMART TRAVELER'S HEALTH KIT

With minimal preparation before your departure, you can be ready to handle most common health problems (and many not so common ones) that might present themselves as you travel. My system for self-care is exquisitely easy. It makes use of a few essential supplies, each with multiple usages. Reading over this chapter you will quickly grasp the basics and the commonsense approach that I advocate. Once you're on the road, in the air, or on the water, the **SYMPTOM-REMEDY INDEX** at the back of the book will guide you to find my suggestions for dealing with hangover, colds, flu, fever, indigestion, tooth-ache, sore throat, nausea, insect bites, infection, minor injuries, diarrhea, constipation, food poisoning, insect repelling, even bedbugs and much more! Your kids may want to get involved all along the way, in packing the kit of supplies and in applying remedies as needed. So, invite their participation as you begin.

This chapter contains the basics for putting together your own Smart Traveler's Health Kit, either the Regular-Size Kit, for the traveler who wants to be self-sufficient, or the Bare Necessities Kit for the traveler who wants to save space and be a bit more creative, or the city traveler who can augment the items called for with a trip to a pharmacy or health food store if necessary.

My previous books, *10 Essential Herbs* and *10 Essential Foods*, also contain advice to travelers. There you may get ideas for additional items that you can prepare in advance to add to your Travel Kit. For instance, in *10 Essential Herbs* I give an herbal formula for "People Paste"—a powder for fixing up almost anything that can go wrong with "people," or pets, both internally and externally.

Your destination will determine what is most needed in your Smart Traveler's Health Kit. An isolated area calls for more preparedness. Your personal sensitivities can also change what you want to carry. For example, if you know that you always get constipated when you travel, make sure that you have plenty of the herbal laxatives that the regular kit suggests. If you know that your digestion always suffers, the digestive enzymes and the umeboshi plum paste, which are listed as Optional Additions at the end of this chapter, will not be options for you, but necessities.

Where to Get Supplies for the Kit

Any good health food store, "bio" store and/or herb store in the United States, Canada or Europe

should have most of what you need for the Smart Traveler's Health Kit. In India, Nepal, other Asian countries and Mexico, the open-air markets will usually have several of the basics I mention, such as salt, garlic, ginger, and cayenne. There are also potent indigenous medicines (such as Ayurveda in India) that the locals love to teach you about. The peppermint essential oil and some of the other ingredients that I suggest can even be purchased at many pharmacies these days.

Storing and Carrying Supplies

I find it convenient to use empty 35mm film containers and heavy-duty resealable zip-lock baggies (the kind used for freezing) for transporting many Health Kit items such as herbs, gauze, tape, etc. These containers and baggies are airtight, waterproof, unbreakable, and made of plastic that is stable enough that it does not deteriorate easily. However, any container with these qualities will do. I avoid glass or aluminum containers, or anything that would break easily, rust, or break down through interactions with herbs, thereby contaminating them (such as happens with aluminum). One exception to this is the very small glass bottle that most essential oils come in. That glass is necessary for the essential oil—the bottle usually has a convenient dropper—and in any case seems heavier to me. I have not had a breakage problem with these.

ŞMART TRAVELER'S HEALTH KITS

I'll begin with listing the supplies you need for each of the kits, and will then give you the lowdown on why I've included each item, plus a basic introduction to how to use it. I've also listed a variety of conditions that each of the items is good for. Consult the **SYMPTOM-REMEDY INDEX** (p. 158) for a more complete listing.

#1 REGULAR SIZE KIT
 Clove essential oil, one small bottle with dropper
 Peppermint essential oil, one small bottle with dropper
 Slippery Elm herb, powder, one or more ounces
 Activated Charcoal in capsules
 Grapefruit Seed Extract, *liquid* form, 2 ounces
 Grapefruit Seed Extract, *tablets, or capsules,* form, 100mg. each, one bottle
 Cayenne Pepper herb, powdered form, one ounce
 Antiseptic Herbal Salve, one small container
 Herbal Laxative capsules
 "Breathable" surgeon's adhesive tape, small roll
 Sterile gauze pads, 3-6 of various sizes
 Non-iodized salt, small container

For this regular size Health Kit, I also stuff, here and there in my baggage, small packets of dry herbs or tea bags.

4

#2 BARE NECESSITIES HEALTH KIT
 Clove essential oil, one small bottle with dropper
 Peppermint essential oil, one small bottle with
 dropper
 Activated Charcoal in capsules
 Grapefruit Seed Extract, 2 ounces *liquid* form
 "Breathable" surgeon's adhesive tape, small roll
 Sterile gauze pads, 3-6 of various sizes
 Additional supplies along the way*

*In this "bare necessities" category I find that I can almost always get fresh herbal antibiotics and antiseptics such as garlic, ginger, onions and salt (a good antiseptic, and good for a nasal rinse and gargle) in small shops or open-air markets even in remote places. These on-the-spot additions are valuable to your travel kit. In the section that follows you will find an explanation about the reason for inclusion of each of the Health Kit items, as well as suggestions for where to get them.

HEALTH KIT SUPPLIES

CLOVE ESSENTIAL OIL

APPLICATION METHODS: Used **externally**, usually diluted 5-10 drops in a teaspoon of vegetable oil, or added to any salve, or in clean water or other "carrier" for dilution. The only **internal** use I would suggest for this oil is using 5-10 drops in 1/4 cup of water as a

gargle for **sore throat**. Even though most Clove Oil is marked "for external use only" it won't hurt you if you swallow a few drops when gargling. But avoid swallowing it regularly over time, even diluted in water, as it might seriously irritate your digestive track.

EXAMPLES OF USE FOR CLOVE OIL:

Antiseptic: Clove oil, as with many essential oils, will kill quite a variety of microbes on contact. For external uses, in addition to the usual dilution method described above, many times I use it full strength. When used full strength externally, it sometimes stings for less than a minute until its numbing properties take over.

Ear pain: For chronic trouble with ear pain during air travel, get Earplanes® special earplugs. (See "Ear Protection" in Chapter 10, Travel Gadgets, for more information.) For ear pain from illness while traveling, until you can locate a doctor use this pain relief and antimicrobial ear formula: In one teaspoon of plain vegetable oil (get it from any market or restaurant), mix in 1 tiny drop of Grapefruit Seed Extract (GSE) (see later in this chapter for explanation of this miraculous substance, and be sure to measure **one drop only**) and two drops of the Clove Essential Oil. Using a dropper or a small spoon, put a few drops in each ear, even if only one ear is hurting. This "quick fix" is often so effective that by the time you find a doctor the source of your ear trouble could be gone.

External pain relief (has a numbing action) of **bug bites**, any painful **skin irritation**, **wounds**: Dilute Clove Oil as suggested above. Rub the diluted oil on the affected area.

Sore throat gargle: Use 5-10 drops of Clove Oil in approximately 1/4 cup of water. You could also put the oil in a large spoon of plain vegetable oil and take tiny sips of the mixture, swallowing slowly so as to let the mixture coat the throat.

Toothache: While you are trying to locate a dentist, one drop of Clove Oil could be rubbed undiluted directly into the gum nearest the pain. This usually stings for less than a minute and then all goes blessedly numb.

HINTS FOR USE WITH CHILDREN: Clove Oil can be used externally for children as described above and even for teething babies. For a teething baby I would always dilute 3 to 5 drops in 1/2 teaspoon of vegetable oil before rubbing it briskly into the gums. One more minute of crying, then the gums go numb and baby often falls asleep.

PEPPERMINT ESSENTIAL OIL

This is the pure essential oil usually from a health food store, "bio" store, or pharmacy. It is not peppermint flavoring. When I buy it, I get a bottle that has an

inset drop-dispenser that is very convenient, leaving no chance of loosing or breaking the loose dropper that comes in other types of conventional dropper-bottles.

APPLICATION METHODS: Used internally and externally. **Internally**, use it diluted. For many internal uses, like **indigestion** and **nausea**, start with one drop of Peppermint Oil in a few ounces of water and sip it over five or ten minutes. You can always add more later and most people overdo it at first. For **respiratory distress** or **general relaxation**, inhale the fumes by putting one or more drops of Peppermint Oil in some water, or on your hand, or on a small bit of cloth to carry around with you perhaps in an open shirt pocket from where the fumes can waft up to your nose. For myself, I have been known to put a trace of Peppermint Oil directly onto the end of my nose! **Externally** you can use it diluted as you wish in any desired carrier (Slippery Elm powder with water to make a peppermint paste; in oil; in aloe vera gel, to name a few). Externally you can also use it undiluted, but always start with trace amounts, adding more later after some experience.

EXAMPLES OF USE FOR PEPPERMINT OIL:

Antiseptic: See External application above.

Bug repellent: Dab traces of the oil on the skin, or put a few drops on a cloth that is then kept exposed from a pocket, or put that Peppermint Oil cloth between

sheets and mattress to help repel **bed bugs** when in the outback.

Bug bites: Rub a trace of Peppermint Oil on the bite.

Headache: Very potent for this. Rub a drop onto each temple and back of neck, but don't get it in your eyes.

Indigestion of all types, including **nausea** from **overeating**: Follow directions for internal use in Application Methods, above.

Motion sickness: Follow directions for internal use in Application Methods, above.

Respiratory or nasal congestion: Inhale its aroma. Breathe aroma from the bottle; or put a few drops in steaming hot liquid such as boiling water and inhale. However, don't boil the Peppermint Oil in the water, as it will quickly evaporate. Add it to already-prepared hot water and use immediately. Also see the ideas in Application Methods, above.

HINTS FOR USE WITH CHILDREN: For children above 5 years old I have used Peppermint Oil internally as I would use with adults, including for **nasal congestion**, **motion sickness** or **indigestion**, starting with one drop in about 6 ounces of water and sipped over 10 minutes or so. After several sips the "patient" often starts gently burping and begins feeling fine again. If fully recovered, there is no need to finish the dose,

unless it is for their pleasure. If you accidentally spill more than one drop into the water, it is best to throw it out and start over, as Peppermint Oil is quite strong and can be over-stimulating to a child's stomach and nose. Once, a group of children saw me putting a tiny drop of Peppermint Oil directly onto my tongue and it smelled so good that, in spite of my warnings, they insisted they wanted to try it. They each applied a tiny trace to the tongue. It so stimulated their saliva flow that they were spitting it out for several minutes!

Another great way to administer it is to put one drop (or more if the child desires) in a small spoon of honey. The child can lick the peppermint-honey over a period of a few minutes (but frankly, most children don't make it last that long, it tastes so good). Sometimes just inhaling the fumes of the Peppermint Oil is enough to bring the desired relief.

SLIPPERY ELM BARK POWDER

This useful herb is a demulcent, which means that it is extremely soothing to the system. It acts as an anti-inflammatory, besides supplying nutritional help.

APPLICATION METHODS: Used **internally** and **external-ly** by wetting the powder either a little or a lot depending upon the use. A little wetting will give you a nice paste for external uses and you can add an essential oil, or other appropriate ingredient such as honey or salve (which won't dry out on you like

water will), to this healing paste as needed. Adding 1-3 teaspoons to a cup of juice, water, or tea will end up giving you a nice drink. It is entirely safe no matter what you do.

EXAMPLES OF USE FOR SLIPPERY ELM POWDER:

Antacid: Use a teaspoon of Slippery Elm powder in some liquid as often as needed.

Antidote: For many irritants, including **hives** (drink in liquid and apply externally), and **bug bites** (use as a paste for a bug bite and perhaps add a few drops of Clove Oil to enhance anti-itching).

Anti-inflammatory: Slippery Elm is so soothing that it can calm down most types of inflammation internally or externally. Inflammation is often at the root of **pain, heat, irritation** such as in **diarrhea, skin rash, fever, bug bites, heartburn, strained body parts** and **wounds.**

Diarrhea: Whether from **food poisoning** or **indigestion** or disease, use 1-3 teaspoons of Slippery Elm powder mixed in a bite of mild food or in juice or water, drunk at least 3 times a day or even many times a day after every loose bowel movement. As diarrhea subsides, less frequent doses are needed. Extra powerful for diarrhea when used along with Activated Charcoal (see pp. 12-14) for this purpose.

Inflammation: See *Anti-inflammatory* above.

Nutrition: Use Slippery Elm as a drink or added to food or swallowed as little "paste pills." Although not an indefinite meal replacement, these nutritional and soothing uses come in handy during or after an illness where you cannot yet tolerate regular meals.

HINTS FOR USE WITH CHILDREN: Use in the forms as suggested for adults but use smaller amounts. Slippery Elm Powder is very safe and can even be used as a food item (mixed in oatmeal, for example, it will add a creamy texture and nutty flavor). There is no need to hesitate in using it with children; the main thing is to think up ways to make it easy for them to use it. It is possible to make small honey-ball pellets that can be swallowed like pills or simply chewed up. To do this, mix honey with the Slippery Elm until you get a clay-like consistency and then roll it into a shape and size for chewing or swallowing. You can add traces of the Clove or Peppermint Oils to these honey-balls when you need their help along with the Slippery Elm qualities.

ACTIVATED CHARCOAL

Especially potent for **diarrhea,** this form of charcoal acts as an absorbent and neutralizer of the most potent type. Absorbs hundreds of times its volume in all sorts of toxic "goodies" that might be ingested while traveling. It is excreted as a very black stool, after

it goes through your digestive tract absorbing irritants and poisons of all sorts and holding them harmlessly bound within the charcoal. So, don't be alarmed when you see the resulting color!

APPLICATION METHODS: **Internally**, swallowed as capsules or powder usually in amounts according to the product label, but also see *Digestive* heading below. **Externally**, if I had no **antiseptic**, I wouldn't hesitate to open a capsule of the Activated Charcoal and pour it directly into an **infected wound** to help absorb the offending microbes until I could find something better for long-term wound care.

EXAMPLES OF USE FOR ACTIVATED CHARCOAL:

Digestive disturbances of every kind including **food poisoning, diarrhea,** and even **acid indigestion**. At the first sign of **intestinal or stomach distress** (or even far after the fact because you "didn't think it would get that bad"), follow the directions on the bottle. However, on several dire occasions my friends and I have used much higher amounts than the bottle suggests, particularly for the tough digestive irritants I have found in India and Mexico.

Caution: You must take any herbs, vitamins, or medicines at least one hour before or after taking the Activated Charcoal, as the Charcoal will absorb those, too, and render them useless.

13

HINTS FOR USE WITH CHILDREN: Activated Charcoal is safe for use with children, especially if they are of an age that they can swallow capsules. Start with half the adult dosage for children under 70 pounds or so and increase if more help is needed. If a child cannot swallow the charcoal capsule, one trick is to take the powder out of the capsule and mix it with honey or a little plain water. There are some children who can handle this and it is worth a try if something serious like food poisoning or extreme diarrhea is present.

GRAPEFRUIT SEED EXTRACT (GSE)

Grapefruit Seed Extract (GSE) is an extremely potent, reliable, and well-researched **antimicrobial**. It kills a huge variety of pathogens including bacteria, parasites, fungus, yeast and even several types of virus. I don't travel anywhere without it. The best source of GSE I have found is called *Citricidal*®. Citricidal® is used in products made by several companies, including the Nutribiotic® company, which is the one I buy. Citricidal® and Nutribiotic® GSE are certified organic and I am confident of their quality.

APPLICATION METHODS: Used **internally** and **externally**. GSE comes in liquid, capsule and tablet form. All of my instructions below are given for using drops of the liquid form, but you can always use one of the other forms. To give an idea of **Correspondence of Dosage Between Liquid and Dry Forms**, and using

14

the Nutribiotic® brand product as a baseline: **10 drops of the GSE liquid is equal to approximately 100 mg. of GSE dry in tablets or capsules.** The tablets and capsules come in various strengths. The liquid form has a greater variety of uses internally and externally, but it must be diluted in a carrier liquid such as water or juice. For **internal use**, some people find that liquid GSE has a bitter taste in plain water; and during traveling, water may be the only available beverage for mixing. However, when mixed in citrus or pineapple juice, GSE is much easier to take, and even most children will drink it.

If you have luggage room for only one form of GSE, take along the liquid. However, if you know you can't handle a bitter flavor and therefore probably wouldn't drink the diluted liquid, even to save your life, take along a bottle of the tablets or capsules, too. If you are only taking the liquid form with you as I do, I highly recommend that you try it in various carrier-liquids before your trip. This will help prepare your tastebuds, and serve your whole system as an **illness preventive.** It will also give you experience in how to mix it.

Caution: Liquid GSE is extremely concentrated and should always be diluted. Undiluted, it can be highly irritating to the internal and external tissues. In tablet or capsule form, some of the bitter, irritating (yet in my opinion healing) principles are removed, and I even know people who have chewed them up with no irritating effect when washed down with water afterward.

15

It is possible to overdo use of Grapefruit Seed Extract, both internally and externally. Although not dangerous, if your skin gets highly irritated or you experience stomach upset, you have probably overdone it. This doesn't necessarily mean you must stop using it altogether. See the notes on this after the following story.

Once in India, when I had an infected earlobe, I forgot my own rule to always dilute the liquid and so rubbed a drop of the undiluted Grapefruit Seed Extract directly into the infected lobe. The next day the infection seemed to be gone, but the surface of the lobe was a little red. I put on another drop of the undiluted stuff "just to be certain," and the following morning the lobe was even redder. Finally I realized I had thoroughly killed any possible infection but had also burned my earlobe! I stopped the concentrate and applied a soothing cream and all was well by the next day.

If a skin irritation develops from using Grapefruit Seed Extract, dilute it even more, or mix it with Slippery Elm Powder or honey as a buffering ingredient, or stop using it altogether. Overdoing it internally can contribute to temporary diarrhea or irritated stomach (some people can't tolerate Grapefruit Seed Extract on an empty stomach although I often take it that way) until your friendly digestive flora build back up.

EXAMPLES OF USE FOR GRAPEFRUIT SEED EXTRACT:

Food poisoning: Following a bout of food poisoning, you will probably find it wise (as I do) to temporarily stop eating anything or to at least limit yourself to eating only simply prepared vegetables and fruits, or just vegetable broth. Depending upon severity of symptoms, immediately begin taking internally 10 to 20 drops or 100 to 200 mg. of GSE 2 to 4 times a day. In between the GSE doses, at least an hour apart, take doses of whatever Pro Biotics you have (see Pro Biotics in Chapter 5). Don't take them both together as the GSE might interfere with the action of the Pro Biotics.

Cleaning fruits and vegetables: There are many other sources of contamination, but the non-hygienic handling of foods and the consumption of contaminated food ranks near the top of the list. I prevent possible food contamination from fruits and vegetables in two ways:

 1. **Peel raw food items before eating.** That means that even though I love the skin of an apple, I don't eat it unless the fruit has been thoroughly detoxified. (See #2). Since that is not commonly possible in travel, I always carry a pocketknife for peeling, and I keep the knife clean by washing it with a Grapefruit Seed Extract solution. (There is still the question of the knife carrying pathogens from the just-peeled skin into the next bit of peeling. I must say, however, that for myself I am taking

17

about 10 drops 2 times a day of the GSE as a preventive dose. When peeling foods I start with a clean knife, and I am not so concerned if during the peeling process I happen to eat some microbes off my now not-perfectly-disinfected knife. Who wants to be worried about disinfecting the knife between every stroke of peeling something? When I have reason to be especially concerned about contamination, or need to prepare larger quantities of food, I apply step #2 first.)

2. **Disinfect raw food items.** I use the Grapefruit Seed Extract, 20 drops or more per gallon of water, to make some disinfecting soak water. I soak all my fresh fruits and vegetables in this solution for at least 20 minutes. Then I eat them as-is, or proceed to peel them at this point with my disinfected knife. An alternative disinfecting agent (especially if the water is not "the worst") is to use a salt water solution. This is not as broad-spectrum a pathogen eliminator as the Grapefruit Seed Extract, but salt water is actually quite good as a disinfectant.

Pre-trip build-up: Start about 10 days before traveling to prepare your system. Take one 125 mg. Nutribiotic® GSE tablet or approximately 12 drops liquid GSE once or twice a day in water or juice. (Usually one dose a day is enough for my 100-pound body.) Depending upon the season and conditions in which I am traveling, especially when I travel in highly contaminated

environments, I keep up this preventive program for the entire journey.

Overall preventive during travel: Using the product called Nutribiotic® GSE, I put 12 drops in about 2 ounces water (juice or other liquid is fine, I just don't have the patience to fuss that much). I hold my breath to drink it down and while still holding my breath I chase it with 8 ounces more of water. That is how bitter it is in plain water! Generally I take this once or twice a day. For long term use, I suggest taking a day off once a week. On one trip, where I was in a remote area and drinking from suspicious-looking wells (bats seemed to live in there and there were "floaters" in the water), I was taking 4 or 5 of the above doses per day. Of course I didn't get sick, but some other travelers who didn't know about using GSE did not fare so well.

Preventing traveler's diarrhea: I have read several doctors' reports that suggest that even as little as 3 to 5 drops once per day is enough for this purpose.

Food preparation on the road: If you are preparing some of your own food, you can confidently clean it of all pathogens by soaking it in GSE water. When added to a tub of water, perhaps 20 drops per gallon, it can be used as a disinfectant for fresh-food items (as well as anything that can handle being soaked in water) and indeed it can disinfect water for drinking but the water will taste extremely bitter.

Disinfect drinking water: I use 10 or more drops (depending upon original source of the water) of Nutribiotic® GSE per gallon of water, stir the water vigorously, then let it stand about five or ten minutes. For most uses with clear water from tap or well, this is enough. However, I have used up to 30 drops per gallon when I had reason to take extra precautions—when I could see contaminants in the water, or when I knew the water source was near pollution sources. See manufacturer instructions and published books in the Bibliography for proportions and details on many disinfecting uses.

Disinfect anything: Externally you can wash or soak any **skin irritation** or **infection** with an antimicrobial solution of 20 drops Grapefruit Seed Extract in 8 to 32 ounces of water, as often as needed. The same solution can also **disinfect items of clothing, personal care items, like your toothbrush and comb, even your child's toys.** Soak for ten minutes, during which time you may want to agitate the item now and then.

Therapeutic dose during illness: No matter what the apparent origin (**bacterial, viral, parasite**, etc.) begin with a therapeutic dose of GSE right away (as compared to the once or twice a day preventive dose). In my experience, an adult over 100 pounds could increase intake to one dose of 20 drops, 3 times a day, and I have even increased to 5 times a day in the most severe cases. Persons weighing less than 100 pounds

usually don't need a maximum therapeutic dose of more than three 20-drop doses a day. It takes some experience to find what is right for yourself. If you are using the plain 125 mg. tablets, an approximate equivalent is 12 drops of liquid GSE equals about one tablet. For a **sore throat** of bacterial, fungal, or viral origin, GSE is fantastic. Put 20-30 drops of GSE in 6-8 ounces water and **gargle** as often as needed.

Hints for Use with Children: Either **internally** or **externally**, always remember to dilute the liquid form of Grapefruit Seed Extract. Many moms have told me their older children, starting at 5 years old, will easily drink 6-10 drops in 6 or more ounces of pineapple or orange juice, as these acidic yet sweet drinks mask the flavor quite well. I have often used it for infants and smaller children at the rate of 3-5 drops in 6 ounces of juice. If a child can swallow tiny tablets, you may want to try the plain 125mg. tablets of Grapefruit Seed extract sold under the brand of Nutribiotic®. The tablet can even be crushed and eaten with a teaspoon of honey or other food. If you are using tablets, an approximate equivalent is 12 drops of liquid to one 125 mg. tablet. Children 50 to 100 pounds usually don't need a maximum therapeutic dose of more than 60 drops or six 125 mg. tablets spread throughout a day. More commonly, in my experience, during an illness you would be using 30 drops a day for children 50-100 pounds, and 20 drops or less for smaller children.

CAYENNE POWDER

Think of Cayenne first and foremost as your "emergency herb" with good reason. Taken **internally** this amazing herb is known to help such conditions as **shock**, **internal bleeding**, even **heart attack**. The Cayenne powder we are talking about is the hot spicy red pepper that many of us associate with Mexican food. It comes in several strengths of "hotness" at most health food stores, and of course most grocery stores. I use it in the dried powder form.

APPLICATION METHODS: For medicinal purposes Cayenne should not be cooked. For the best medicinal action it is used as a loose powder (not in capsules) in order to interact with important processes in the mouth. If you get it in capsules you can always open up the capsules and use the powder mixed in a little water or juice. Used **internally** and **externally**, the dose varies greatly from person to person and use to use. For **internal** use, start with a pinch of Cayenne in a little water or juice. Increase from there until it is definitely hot in your mouth and warm in your stomach, but not so strong that it is nauseating. A **common medicinal dose** is 1/4 teaspoon (or more) in some juice or water. It is in the chemical nature of Cayenne that, with continued use, most users quickly build a tolerance for its hotness. Each individual's optimal dose of Cayenne is unique and it is possible to temporarily get diarrhea from taking too much Cayenne internally (see *Constipation* below). An antidote for

"hot mouth or stomach" is to eat some milk-based product such as yogurt or cheese.

EXAMPLES OF USE FOR CAYENNE:

Bleeding: Internally, from ulcers or injury, take one or more internal doses as indicated above.

Bleeding externally, apply Cayenne powder straight into a wound to help stop bleeding. If wound is bleeding profusely, apply the Cayenne and then maintain pressure on the wound. In my experience the only time Cayenne has stung in a wound is in a nerve-concentrated area such as a fingertip.

Caffeine habit breaker: Use Cayenne as a stimulant in place of caffeine. Mix 1/4 teaspoon or more in 4 ounces of water or juice. There is an entire chapter on its abundant healing uses, including details about its use for replacing caffeine, in my book *10 Essential Herbs*. (Also see instructions in *Circulation*, below.)

Circulation: One dose of approximately 1/4 teaspoon (see Application Methods above) 2-3 times a day as a tonic for heart, blood and circulation. Feeling cold? Cayenne mixed with grape juice (see *Stimulation*) will warm you up as it can increase your circulation even to those cold extremities, stimulate digestion, give you a clear head, give you a good dose of minerals and iron in the grape juice, and help relieve the compelling desire to hibernate (i.e., oversleep). You

23

can use this concoction as often as you wish. If you are not used to Cayenne, start with less than I recommend and build up. Also look up the instructions for Honeygar in Chapter 5 and drink it hot. Add a pinch of Cayenne to the Honeygar for an extra kick.

Cold hands and feet: See *Circulation*.

Constipation: Cayenne in doses higher than you would normally tolerate (this is an individual assessment), is a great **intestinal stimulant** and can really get things moving. Start with twice the dose you would normally tolerate, mix it in some water or juice, and wait a couple of hours. If no "action" occurs, do it again. For myself, with and sometimes without a small amount of food in my stomach, I use 1/2 teaspoon in water, which usually does the trick, but I definitely go for a glass of plain water after that hot blast. I have a friend who has to take this dose 3 times during the day. An antidote for "hot mouth" is to take one or two spoons of yogurt or a small amount of other milk product. But don't overdo the milk-based items until you get things moving again!

Digestive aid: Drink 1/8 teaspoon or more Cayenne in water or juice before and/or after a meal to enhance digestion. If any part of a meal is not going down so well, sprinkle some Cayenne on it.

Frostbite of an appendage: Soak as needed in Cayenne water. Mix 1 or 2 tablespoons of Cayenne for each

room temperature (tepid) gallon of water. Also, for additional help with frostbite and other symptoms of overexposure to the elements look in Chapter 2, Hydration is Life, page 50.

Heart attack: Use 1/2 to 1 teaspoon powdered Cayenne in 8 ounces water and have the person drink it in small swallows, every few minutes, while seeking medical aid. Definitely do not drink it all at once, and lessen intake as symptoms subside. If person is unconscious, put a small pinch of dry Cayenne powder on tongue or tucked inside lip. When used in this way, Cayenne has saved lives.

Headaches: With headaches caused by everything from **hangover** to **overeating** to **tension** to **jet lag**, Cayenne is the first thing to try. Use one dose every 5-10 minutes as needed until stabilized.

Shock: Help prevent shock in a victim during an emergency. Administer a double dose of Cayenne in liquid, having the person take small swallows until shock symptoms clear or are prevented. Put a pinch of dry powder directly in the mouth of an unconscious person.

Stimulation: Avoid caffeine. As a caffeine substitute, go for 1/4 teaspoon Cayenne powder mixed in 8 ounces of real grape juice (not artificially flavored "grape drink"). Grape juice is best but other juices can work fairly well.

HINTS FOR USE WITH CHILDREN: Do not use Cayenne for children unless it is in an **emergency** to prevent **shock**. If a child is in shock, they do not taste the hotness of the Cayenne, and it is no problem to administer it in doses of 1/4 teaspoon mixed in 4 ounces of juice or water and sipped in small spoonfuls every 3-5 minutes until they report it is hot to their taste.

ANTISEPTIC HERBAL SALVE

At your health food store, "bio" store or in some pharmacies find an herbal salve that has potent antimicrobial ingredients such as honeybee propolis, pine sap, comfrey root, goldenseal root, and oregon grape root, to name just a few valuable ingredients. Find one preferably made with beeswax and oil as a base and avoid those with a petroleum base. A knowledgeable health food or herb store attendant may have helpful suggestions here.

APPLICATION METHOD: FOR EXTERNAL USE ONLY. Apply directly on the affected area, covering the area if necessary. If the salve or oozing wound will be sticking to dirt or clothing, be exposed to contamination while on the road, etc., then I would bandage the area. Generally, however, I like to leave a wound uncovered for at least part of the time, especially if it is being kept too damp by having a protective covering all day, making it less likely to scab over. Uncovering helps it dry out and heal and this might be easiest at night

(that is, if you are not out partying). You will often want to disinfect and/or clean an area with salt water or diluted Grapefruit Seed Extract before you dry it, apply the Antiseptic Salve, and bandage the area.

EXAMPLES OF USE FOR ANTISEPTIC SALVE:

Rashes	**Wounds**	**Infected sores**
Scratches	**Pimples**	**Dry nose (inside)**
Bug bites	**Blisters**	**Sunburn or wind burn**
Chapped lips		

HINTS FOR USE WITH CHILDREN: You can use Antiseptic Herbal Salve freely with children and most salves are great for diaper rash in infants as well. It is wise to buy a Salve with pure ingredients, such as herbs, vegetable oils, and beeswax and to avoid those based in petroleum and those using synthetic fragrances and ingredients because, as you know, a child might get some in his mouth. A good Herbal Salve should be basically edible.

HERBAL LAXATIVE

If you need a laxative while traveling you probably need something strong. Sometimes a few doses of Cayenne will get the bowels moving and keep them going. (See *Constipation* under the **Cayenne** heading, this chapter.) However it is a good idea to have some herbal laxative capsules handy.

It may seem odd, but **headaches, tiredness, depression, skin blemishes** and a whole host of other **"congestion type" symptoms** are often caused by constipation (congestion of the bowels) and therefore an Herbal Laxative can be a great help for many purposes. Even the ordinary changes in diet that travelers will naturally experience are just as likely to result in constipation as in diarrhea. In addition, constipation sets the body up to be a breeding ground for illness. Do your best to encourage your bowels to move a couple of times a day. (Forget what we all learned in our childhood health education which was that if your bowels move once every few days that would be okay, "normal," and nothing to be concerned about!) Look for an Herbal Laxative formula with ingredients such as cascara sagrada, senna, aloe, turkey rhubarb, slippery elm, cayenne and ginger. It is also well known that one must drink a minimum of 2 quarts (or liters) of water a day for the bowels to have enough liquid for healthy function. Not enough water results in dry, hard, or even non-existent bowel movements.

It is so important to a traveler's health to keep the body eliminating properly, that if you stay constipated more than a day after drinking more water and taking a strong dose of Herbal Laxative, it would be wise to switch to eating only fruits and vegetables for a couple of days, or to fast on water for one day while continuing with the Herbal Laxative, in order to help get the system cleared out.

APPLICATION METHOD: Herbal Laxatives come in many forms, including tablets, capsules, powders, and teas. Follow manufacturer's directions. Generally use the herbal laxative at night before sleeping. If more help is needed, use more Herbal Laxative in the morning.

Remember, the advice here is for traveler's usage. Since one can become dependent upon laxatives, herbal and otherwise, consult your doctor about long term use.

EXAMPLES OF USE FOR HERBAL LAXATIVE:

Constipation: Follow product directions.

Overall "sickly, sluggish feeling": Take Laxative according to directions on product.

Congestion (nasal, lung, **headache**, especially when constipation is also present): Take Laxative according to directions on product.

Digestive distress: Another occasional use for a Laxative is when you sense that a meal you have just eaten is quickly turning to cement in your guts. It's almost as if your digestion has just shut down for a while, it was so overwhelmed. We have all been there. First, take a 1/4 teaspoon dose of Cayenne to stimulate circulation in the stomach and elsewhere. Repeat this in 30 minutes if you like. Next, take a dose of Herbal Laxative before sleeping and upon awakening, and make certain you are drinking 2 liters of water in

29

a day, or more than 2 liters of water if you have been drinking alcohol.

HINTS FOR USE WITH CHILDREN: I have known a child who while traveling got so severely constipated that there was no bowel movement for days and sickness was resulting. Most commonly I find children get constipated when they do not like unfamiliar tastes and textures of food. This leads them to overdo sweets and foods such as pasta, white rice and white breads. These foods make a paste in the gut that quickly discourages natural elimination processes. An Herbal Laxative would be fine to use occasionally for a child, and preferably long before the situation was so bad that there were no bowel movements for days. After a day of little or no movements, give the child one capsule of Herbal Laxative before bed and one in the morning if still needed. Increase by one capsule at night and one in the morning until results are satisfactory. With small children who cannot swallow capsules, take along a liquid form laxative. Although this will probably taste strong to the child, you can mask it with juice or honey. If possible, have the child eat laxative foods such as prunes, figs, or raisins. Always check to see if the child is drinking enough water—at least an ounce for every two pounds of body weight; or at least a liter a day for a child from 40 to 70 pounds.

NON-IODIZED SALT

Non-iodized sea salt is best, but any salt will do when you need it. You can get salt just about anywhere in the world, but it pays off to be a prepared traveler by carrying along a small container for use at a moment's notice. You can always replenish your supply later.

Salt water is a potent and entirely safe external antimicrobial, killing a broad spectrum of **bacteria, yeasts**, some **viruses** and **external parasites** such as might be found along with **irritated skin symptoms**. If you understand this piece of information correctly, you will now know that this is an incredibly inexpensive, highly potent source of help for travelers. It does duplicate some of the actions of the Grapefruit Seed Extract, but Salt Water is more easily applied as a rinse for delicate nasal membranes and you can keep replenishing the supply almost anywhere (which is not the case with the Extract).

APPLICATION METHODS: For **internal use**, like a **nasal rinse** (see directions below) or **gargle**, use a mild Salt Water solution of about 1/4 teaspoon Salt per cup of clean water. For **external use**, such as for **soaking infections**, use 1/2 to 1 teaspoon of Salt per cup of clean water. These measurements don't have to be exact at all, but you can irritate your nose if you make it too strong for that purpose.

31

HOW TO DO A NASAL RINSE: Use a small cup or glass or large spoon to hold the Salt-Water solution up near your nose. Gently inhale the solution up one nostril while you hold the other nostril closed. Keep inhaling slowly and the solution will begin to drip down into the back of your throat. Stop. Spit out the solution and blow your nose as needed. Do the procedure on the other nostril. Repeat, as needed.

Of course you are bound to swallow a small amount of the Salt-Water solution, and this is okay. Just don't drink the stuff thinking it will help you internally, as you will probably at least get nauseous and have a bad stomachache—possibly (albeit temporarily) making the "cure" worse than the ailment.

It is worthwhile to note that a great many **bacteria and parasites** first get a hold on the body through entering the nasal passages and breeding there before moving deeper into the body. If you stop them in their tracks within the nasal passages, using a Salt-Water nasal rinse, you won't get sick at all. This nasal rinse is a little known, but powerful, health protection trick that can leave the "I'm already sick" remedies left unused in your bag. Especially useful for travel in polluted cities.

Once while traveling in Kathmandu I realized I had landed in air pollution hell. An Irish nurse from the local hospital confirmed my suspicions by telling me that the area was known for its extremely high incidence of respiratory diseases of all types. Within two days of being there, almost

all the other Westerners I was traveling with had joined the local population in a type of coughing, sneezing and wheezing that often escalated into fevers, swollen nasal passages, and infectious nasal and lung discharges, to name just a few symptoms. I had suggested that everybody try Salt Water as a nasal rinse, but most of my fellow travelers apparently preferred the "slow death" scenario of increased respiratory suffering. I think the problem for many was partly a social etiquette question and partly a sensitivity about such a hands-on experience with nasal effluents. I agree that the circumstances in which we were traveling were far from offering Western-style toilet facilities for nasal snorting in private.

A friend and I took our Salt Water nasal rinse onto a third story "balcony" of what you could loosely call our "accommodations." We rinsed our nasal passages and blew the results as best we could out over the balcony to the garbage heap below. At the end of each day we would feel the beginning build-up of the same symptoms of respiratory infections that were attacking our companions, but we continued on with our Salt Water prevention and kept our strength for the many adventures ahead.

The result? My friend and I were the only ones who did not suffer a respiratory infection out of over twenty Westerners on our trip, and I am certain it was largely due to these simple preventive methods.

Caution: the only drawback to this system is that Salt Water up your nose every day can be drying to nasal mucous membranes. When I felt this occurring, I always put a few drops of oil, lotion, or the herbal salve, from my travel kit, up my nose after each rinse.

EXAMPLES OF USE FOR SALT:

Cold or Flu: Stop or slow symptoms with a Salt-Water nasal rinse even if you don't have nasal symptoms. Use Salt Water as a gargle for **throat symptoms**. See instructions above.

Fruit and vegetable cleaner: I know that many **parasites**, **bacteria**, **viruses** and **fungi** cannot live in Salt Water. I use about 1 to 2 tablespoons Salt for 3-4 liters of water, and soak the fruits and veggies for 20 minutes.

Infection soak: There is no time limit, but in general I like to soak an infected area at least 20 minutes, from one to several times a days, depending upon the severity of the infection. If the infected area includes broken skin, the Salt Water sometimes does sting. If it is too unpleasant, simply stop soaking and let the area dry. Rinse the area with plain water if you need to, but otherwise it is fine to let the Salt Water simply dry on the skin. If you can get it, using warm water for a Salt Water soak is very good, but not crucial. As an external soak against extra tough infections (not a nasal rinse), you can add a few drops of Grapefruit

34

Seed Extract to your Salt Water. I use both items for different purposes and sometimes this depends simply on what I have on hand.

Respiratory ailment: Especially use the nasal rinse described above.

HINTS FOR USE WITH CHILDREN: I have taught several children over the age of 7 to do a nasal rinse, but it is not the usual thing for a child to learn, that's for sure! For a child in need and who is willing (never force a child to do this) it can be helpful to have him or her lie down while you carefully administer a few drops of salt water into each nostril. After a moment she should then sit up, as it will run down into the back of her throat and she can spit it out and then blow her nose. The nasal rinse mixture should be well diluted for a child's delicate nasal membranes, so start with 1/8 to 1/4 teaspoon Salt in 1/2 cup of water. Externally Salt Water is used the same for children as for adults when soaking an infected area.

BANDAGING SUPPLIES

There is nothing esoteric about my choices here and you can feel free to choose the materials of your choice.

HINTS FOR USE WITH CHILDREN: Most children will appreciate decorative bandaging and some sort of tape that doesn't pull their skin painfully upon removal.

ADDITIONS TO THE HEALTH KIT
Optional, But Highly Recommended

PLANT-BASED DIGESTIVE ENZYMES. This item can prevent or quickly turn around **digestive errors**. The liver and other organs naturally produce digestive enzymes which help in the breakdown and assimilation of all different categories of foods such as sugar, dairy products, carbohydrate, protein, fiber, etc. When our **digestion gets overloaded or over-stressed**, as happens with new foods, or from a diet of mostly cooked and processed foods, or with **overeating,** illness and other circumstances, we are usually not producing enough enzymes to do a proper digestive job and so much of our food can become a gas-producing internal compost heap, so to speak, partially digested or completely undigested. This causes all sorts of problems for travelers and contributes to just about every health problem mentioned in this chapter.

At the first sign of digestive upset, supplementing with Digestive Enzymes can help tremendously. Enzymes are also marvelous in ridding the body of many types of pathogens, since some of these enzymes are specific for digesting proteins, and most pathogens—from bacteria to parasites—are made of proteins. I have even used digestive enzymes in-between meals to help digest plant pollens that were causing **allergic symptoms**. Once again this works because pollens are proteins!

If Digestive Enzymes are taken before, and/or during, and/or after a meal (depending on how dire the digestive circumstance), you will find that your digestive capacity takes a huge leap forward and you are more likely to feel great after yet another feast, instead of swollen, gassy and bogged down as can happen on our so-called "vacations" and "adventures." I often just carry a few in my pocket if I am strolling through a village or a city for the day, because I know that I love to eat all sorts of new things that sometimes don't end up going down so well.

Any health food store will carry plant-based Digestive Enzymes and some will work in a broader range of digestive chemistries as compared to others. Tablets or capsules are usually small and lightweight, and they don't spoil if kept dry and dark. Get a formula that includes a variety of plant-based enzymes, such as protease (for proteins), lipase (for fats), sucrase (for sugars), lactase (milk products), and amylase (for carbohydrates).

Several fresh foods have a high amount of naturally-occurring Digestive Enzymes that are quite effective in assisting digestion: Most potent in the fresh form, you can use papaya, pineapple, apple, figs (fresh and dried), wild yam, and mango.

Herbs, both fresh and dried, that are wonderful for **digestion**, and which can usually be found in most world markets, include hot peppers, fennel, anise, turmeric, cumin and ginger. You will easily learn what local herbs are used for digestion by asking the herb vendor. Many times when I could not

speak a language, I have pantomimed my question about indigestion and have been immediately helped with a new recommendation. Every time you learn one of these tricks, it is one less thing you have to carry in your bags. This is what I like.

HINTS FOR USE WITH CHILDREN: Children can especially benefit from the help of plant-based Digestive Enzymes. Since children's diets tend to have more sugars and starches in them, at least one company, Prevail®, makes a special formulation for children that takes this into account. A stomachache from unaccustomed foods is easily handled and can even be prevented with a little planning. Get a formula that comes in a capsule and then you can simply open the capsule and mix the powder in with a little food, water, honey. Or the child can lick up the powder as-is, since it has a bland flavor that most anyone can easily handle.

PRO BIOTIC SOURCE: See Chapter 5 for details.

UMEBOSHI PLUM PASTE CONCENTRATE. This is a salted Japanese plum product available in health food stores. It comes in several forms and I only use the concentrated form for traveling. The concentrate is a dark brown, sticky paste and comes in a small fat jar for easy packing. It is a powerful **digestive aid**, vermifuge (**kills parasites**), **antibacterial** and **appetite-balancing** agent—either up or down. It can stop **nausea** instantly, stop many types of **food poi-**

soning and remedy some **intestinal complaints**. May be taken before, after, or in-between meals. It has a highly appealing (to me), tart and salty taste.

ARNICA HOMEOPATHIC MEDICINE. This is a medicine used to stop **shock** from a variety of traumas, whether physical or emotional, bringing body metabolism back to normal. It is also used for the "shock" of the effects of illness. Any type of **overexposure** to the elements (**frostbite, heat prostration, sunburn**) is also a good time to use it.

SUPERFOOD SOURCE. See Chapter 4.

TONIC INGREDIENTS. See Chapter 5.

2.

HYDRATION IS LIFE

Many of us are cautious, and rightly so, about drinking the local water when we travel. Countless vacations, backcountry treks and business trips have been ruined by illness from ingesting contaminated water. Especially in Third World countries, the drinking water can be hazardous to non-residents, and even bottled water is not always completely reliable. Yet, bar none, the best traveler's health aid is clean drinking water.

Water is the primary agent for diluting, dissolving, and carrying out of the body all sorts of pollutants and wastes. It is also a primary carrier of nutrients into all the cells of the body.

For a traveler, this means that finding clean water and drinking enough to keep properly hydrated is the bottom line for maintaining the health and energy resources you need. Many of the symptoms of ill health experienced in travel start with little-noticed

signs of dehydration. Some people still believe that feeling thirsty is the first sign of needing more water. Actually, a **grumpy mood, fatigue, headache,** a **stomachache, constipation** or **mucous congestion** are often noticed before thirst. Of course these symptoms might also indicate other conditions, but many illnesses often start with dehydration, so it can't hurt to drink more water whenever we feel "off." **Short of breath? Muscles ache? Cramps? Depression? Constipation?** . . . The list of symptoms of dehydration goes on and on . . . **Hangover?** Quite simply, you used up all your internal water supplies surviving the party, and now your body systems are dehydrated and can't handle the toxins quickly enough. The remedy? Drink an extra liter of water right away!

Brain chemicals called neurotransmitters are responsible for balanced mood and clear thinking, and they need plenty of water to operate. **Traveler's fatigue** (which feels like a "brain cloud") is common with particularly long bouts on an airplane, during a mountain trek, or in the midst of an excruciatingly long business meeting. Here again, immediate relief may be as simple as drinking an extra liter of water.

Another eye-opener on this topic is that eating predominately cooked and highly processed foods (as most travelers do) is a leading factor in dehydration. When thirsty, however, many people head for the soft drink stand, even though soft drinks tend to increase the overall dehydration. As a traveler, therefore, "Drink more water!" should become your motto, and your first response, health-wise.

HOW TO GET "CLEAN" WATER

- **Buy bottled water.** Even though some bottled
water may be no better than tap water, as its pro-
cessing and bottling is regulated very little in
many countries, including the United States, I'm
willing to take the chance on it when I am in the
U.S., Canada or Western Europe. I highly recom-
mend reading the label, looking for a brand that
says "purified by reverse osmosis" or some such
reassuring phrase. This water will generally not
taste like treatment chemicals, whatever else
might be in it. I avoid those brands that simply
say "drinking water." In other parts of the world,
particularly in Third World countries, it is riskier,
but still bottled water is my choice if I don't have
one of my water purifying gadgets with me (I'll
mention these later). Spring water can be a good
choice, particularly if you recognize the brand.
- **Order non-carbonated bottled water in restau-
rants.** The table water served in most restaurants
is simply whatever comes out of the kitchen
faucet. With all the treatment chemicals added,
this liquid, in my opinion, does not count for
clean water. We probably all know someone who
has had a "near death" experience using so-called
drinking water, or tap water, while traveling.
During one of my trips I bought a small cup of
carrot juice each day and felt great. So good that I
decided to try the large size. Bad idea! I got sick.
Later, I learned that the difference between

"small" and "large" was the tap water added to the larger size!

- **Bottled soft drinks** are usually safe as far as microbes go, and are easily available almost anywhere in the world. Even in the alleys of remote villages I have often found a soft drink vendor. Prefer glass bottles over aluminum containers, and firmly avoid diet sodas of all types if there is any choice at all, as their sweeteners are so highly toxic (see *Safe Shoppers Bible* in the Bibliography). This is especially important for the mental and physical health of children, as these diet drinks commonly contain the highly toxic ingredient Aspartame (a.k.a. NutraSweet® and Equal®).

 While I hope that soft drinks (carbonated beverages) will not have to be your main source of water, they are a source of liquid, and despite their high chemical content, which is somewhat dehydrating in itself, drinking carbonated beverages would often be better than consuming pathogen-contaminated water, if you had to make that choice. However, if they are your sole or major source of water, you may experience the side effects of all that sugar, coloring, chemicals, etc. If sugary beverages are your main water source, give yourself a couple of doses a day of Cayenne from your Smart Traveler's Health Kit (see Chapter 1).

- **Tea and coffee.** These are safest to drink if you get them extremely hot. If they are cold or room temperature, it is anybody's guess if the water in

them is safe or not. The tea served in village tea stalls is a fairly safe bet, even in out of the way parts of Asia or Latin America, and especially if you can see that the operator of the stall is standing there boiling the tea all day long and thus inadvertently sterilizing it. Avoid doing what one of my friends did, however, which was to take the "sterilized" tea and then to use the publicly licked sugar spoon sitting on the counter top to stir in the fly-specked sugar! He felt really ugly for a day or so and I always suspected it was that spoon and that sugar. Fortunately, Grapefruit Seed Extract helped his recovery!

- **Eat watery fruits.** All types of citrus fruits and apples are a wonderful source of electrolyte-rich water. Make sure that you can cleanly peel the fruits, however. I have traveled in remote or tropical places where my main source of water for many days was citrus, pomegranates and apples, and I felt fantastic.

- **Purify or filter your own water.** As it will not always be possible to purchase safe bottled water, especially in remote areas, the health-conscious traveler will want to have a back-up system for purifying or filtering water all along the way. In the next section under **For Purifying**, and in Chapter 10, Travel Gadgets, you will learn my recommendations on this vital subject.

Making Your Own Clean Water

- **Boil it.** If you can have your water boiled for approximately 20 minutes, most, if not all, pathogens will be killed. However, boiling takes a fuel source that is expensive in some countries and especially in remote areas. On several occasions when I requested boiled water it was brought to me so fast that I went to check on what was happening. It turned out that it was considered highly wasteful to use fuel for boiling any longer than needed to bring the water to the initial boil—not enough time to purify it.

 In populated areas, as I discovered, the best source for boiled water was from tea shops where water was kept boiling all the time. I would watch until the new batch of water had been boiling long enough and then I would buy some. Shopkeepers considered me odd for asking for the water plain without the tea, but since I was a paying customer they obliged.

- **For purifying,** I want something that will kill at least 99% of bacteria, virus, fungi, parasites, amoebae, and other pathogenic microbes. With such a gadget, even tap water in a restaurant or well water from the countryside can be made clean of pathogens. One such amazing item is the Steri-Pen® made by Hydro-Photon, which uses ultraviolet light to do the job and cleans up to 16 ounces of water at a time. It is hand held, about the size of a small flashlight, and uses four AA

45

alkaline or lithium batteries to provide up to 130 UV sterilizing "zaps" between battery changes. It costs less than $200 and is built so tough that it should last through years of the most rigorous use. If you are on an adventure where the available water has "floaters" in it of some type, remove the bulk of these sediments first by filtering the water through a fine-mesh cloth such as a cotton sari, skirt or shirt. In a pinch, simply let the sediments settle to the bottom of a container and then carefully pour the relatively clear water off. (Refer to Chapter 10 for more information.)

- **A travel water filter** is another good choice. A specialty backpacking store will be able to provide a very small, high efficiency water filter, which instead of killing pathogens simply eliminates many of them through micro-filtration. Usually you pour water through it, pump water through it, or hook it up to a faucet. The smaller the micron measurement of the filtering technology, the more pathogens removed. Look for one that filters down to .5 (1/2) microns. A travel water filter might also remove some chemical residues. It can cost less than $100 and even the less expensive smaller ones can produce 500 gallons of filtering before needing a filter change.

The essential information about a filter is to confirm exactly what will be filtered out of the water. For example, if it only filters out chemicals and bacteria there are still plenty of much smaller critters such as parasites and virus getting

through. However there are some very good travel filters out there and worth checking into.

If I had to choose between these two technologies, filter or purifier, my choice would depend a lot upon where I was going. If my travel was fairly civilized, I would probably go for the Steri-Pen®. Even though it does not remove chemical residues and sediments, I would rather drink the usual water-treatment chemicals, when absolutely necessary, rather than the pathogens that can be left behind by most filters. Also the Steri-Pen® is small. You can just whip it out of your purse or pack at a moment's notice and zap the water you want to drink for about 40 seconds. That's it.

If I needed sediment or chemical removal as well as pathogen removal, I might go for the best small-size filter I could find. Even though most filters don't eliminate nearly the range of pathogens as the Steri-Pen®, a good filter gives some potent help in both areas of pathogens and chemicals. I suppose if you love gadgets and have the room for it, you could take both! Look in the Buyers Guide, Chapter 12, for water purifying and filtering devices.

- **Water-Disinfecting Additives.** Grapefruit Seed Extract (GSE) is the most potent, proven and tested raw material with the least possible side effects (if any) I have found for disinfecting water naturally. My brand of choice for GSE is *Citricidal®*. Citricidal® is used in products made by several

companies including the Nutribiotic® company. This is the brand of GSE that I buy.

If you have made yourself a Smart Traveler's Health Kit (see Chapter 1) then you will always have GSE on hand. Where safe drinking water is not obtainable and boiling is not possible, I add Citricidal® to my water, usually in the liquid form of Nutribiotic® GSE, even though it leaves a bitter taste in the water. For disinfecting clean-looking water, mix 10 drops into a gallon of water, stir it vigorously and then let it stand for five or ten minutes. Because this leaves the water tasting bitter, it is usually not the first choice for this disinfecting job for those who are "bitter challenged." However, when you drink this water you get its pathogen-killing properties added to your blood. The bitter flavor can be covered somewhat by adding to one liter of disinfected water, one drop of the peppermint essential oil from your Traveler's Health Kit. (See more specifics on GSE for water purification under *Disinfect drinking water* in Chapter 1, Smart Traveler's Health Kit.)

You can also get various water purification tablets, including Iodine tablets, from most pharmacies. Follow the directions on the label.

How Much Water Each Day?

As a general guideline, divide your pounds of body weight in half and drink that amount of water in ounces each day. For example, a person who weighs 150 pounds would do well to drink at least 75 ounces

(about 2 1/4 quarts or liters) of clean water each day. If there are other dehydrating circumstances—such as air travel, high temperatures, illness, physical exertion, use of alcohol, and so on—then the traveler should make efforts to drink even more water. Drinking tea, juice, soda, or coffee is not the same to the body as using plain water. However, a traveler must make the best of every circumstance and since clean water is not always easily available, these alternate beverages can count toward the total of needed water. [For those on the metric system, a pound equals 450 grams and an ounce equals 29.6 ml.]

What About Alcoholic Beverages?

Red wine has health promoting properties and is a fair source of water, even though part of the water is used to metabolize the dehydrating effects of the alcohol. Beer can be an okay alternative when plain water is not available, and in countries such as Germany there are even stringent quality controls placed on the water used and on the types of additives (almost none).

However, I have known many beer drinkers who swear they are keeping well hydrated with drinking beer. They point to their copious production of urine as proof of this. What they don't realize is that their urine contains extra water taken from other bodily processes—water that is necessary to counterbalance the stressful chemistry of alcohol. This results in a type of dehydration that can sneak up as a **hangover, bad mood** and **traveler's fatigue**. Since alcoholic beverages

greatly dehydrate, the smart drinker, in addition to the average daily water needed, will drink an additional quantity of water equal to the amount of alcoholic beverages consumed. (Yes, that will be a lot of water for some travelers.) When water is scarce, however, the situation is more difficult.

SPECIAL HINT TO ALL: See Chapter 5, about tonics, and learn about the amazing qualities of Honeygar. Adding this wonderful elixir to your drinking water will greatly increase the electrolyte quality of the water and therefore increase the amount of rehydration benefit for each swallow you take.

Other Uses for Water

Frozen or burnt? **Overexposure to the elements** can seriously curtail your vacation fun. Whether for **sunburn**, **heat prostration**, or **frostbite**, the first priority is to drink plenty of extra water at room temperature, or slightly cooler or warmer. Don't drink iced or boiling hot water. The idea is to readjust and normalize body metabolism and body functions shocked by these extreme exposures and to rehydrate. Soak a sunburnt or frostbitten appendage, or the entire body, for at least half an hour in a tub of normal body-temperature water (you can adjust the temperature up or down a little after you have been soaking a few minutes, but don't go to extremes) to which has been added either 1/2 cup of vinegar, or strong peppermint tea—1 teaspoon herb per cup of water and steeped for half an hour or more to get it extra

strong— strained, and added to the tub (any mint tea will do as second choice to peppermint). In most Western countries it is quite easy to find peppermint herbal tea bags (herbal tea in Europe is sometimes called *tisane*), and these are convenient for making a tea-bath. For myself, for **heat prostration**, I have used the vinegar and peppermint tea mixed together in the same bath with fabulous results, but I have to warn you that the aroma of that mixture may not suit a sensitive nose. For **heat exposure** be sure to immerse your head in the peppermint tea-bath or vinegar bath as well. Don't use peppermint oil as it will not blend with the bath water.

If you are in a tropical climate with tropical fruits available, raw papaya or mango is perfect to mash and place on a severe **sunburn**.

3.

HEALTHY FOOD EVERYWHERE

This chapter will cover the two basic food situations that you will encounter while traveling. First, the Do-It-Yourself approach, where you are shopping for and preparing your own food and beverages, either before you leave or as you travel. Second, the Restaurant or Food Counter scenario, in which you eat from a menu of meals prepared by others. Many travelers will do some of each, so be sure to read about both of these categories below.

Whatever food-choice situations you expect to find yourself in, the smart traveler needs to be on the lookout for those foods that support overall health and healing with exceptionally good nutrition. These always deserve their place at the top of your list of food choices.

Healthy foods, in my definition, include most fresh and unprocessed (not frozen or canned!) "live" foods, such as fresh kale, broccoli, fresh ripe berries, prunes, raisins, red bell peppers, red grapes, papaya,

sprouts (alfalfa and others), lemons, raw nuts and seeds, fermented foods such as sauerkraut and pickles, fresh corn and spinach, dark leafy greens of all types, fresh fish, and healthy oils such as extra-virgin olive oil and flaxseed oil.

My book *10 Essential Foods* is all about healthy food. Here you will learn about the unsurpassed value of raw almonds, broccoli, carrots, sea vegetables, brown rice, grapefruits and other great sources of nutrition. I also include Traveler's Tips and Survival Choices in that book that you could put to great use as you plan your next trip.

DO-IT-YOURSELF WITH FOODS AND BEVERAGES

This section will cover the following topics:
* **Travel snacks** * **Travel beverages** * **Desserts**
* **Fresh Fruits and Vegetables, including Sprouts**

TRAVEL SNACKS—**Rejuvenate at a Moment's Notice**

A good Travel Snack can't spoil easily, needs no refrigeration, is lightweight and is carried in an unbreakable container. It should also taste great, boost energy and stamina, require limited processing in its making, make minimal mess to carry and eat, and balance both mind and body.

The Travel Snacks I recommend here have much in common with the Superfoods (see Chapter 4), and

indeed it is sometimes hard to point out a difference unless it is that many of these snacks lend themselves to being eaten more often throughout the day as they are somewhat less concentrated. Also, some of these snack items can be replenished more easily as you travel, whereas some of the Superfoods need more specialized knowledge of resources to obtain them. Between Travel Snacks and Superfoods you should *never* be out of ideas to repair, replenish and rejuvenate yourself at a moment's notice under any circumstance, however elegant or rustic, conventional or bohemian.

Before I list my Travel Snack Favorites, however, I want to discuss this issue of airline food and my experience with eating it.

Airline Food Oxymoron?

Except for some of the beverages offered, I have a habit of not eating airplane food as I find it so extremely disappointing (to put it politely), and generally devitalizing. I have tried all sorts of the so-called "alternative choice meals" on many different airlines, from the vegetarian Indian, to the fruit plates (dead limp bits of "fresh" fruit cut up on a plate), to the lacto-ovo vegetarian. Of these choices probably the vegetarian Indian was the best of the lot, but it didn't win any big prize. Certainly I have demanding standards, and yes the meals were quite disappointing.

One of my carry-ons is always my food bag. What I do is prepare some delicious yet travel-stable foods to take along. Of course it is all going to be room

temperature and I take this into account. Some of my favorites foods are tuna salad (made with a wonderful olive oil/mustard/curry-spice dressing instead of mayonnaise) with crackers, goat cheese on rye bread, fruit, stuffed baked potato, sandwiches of all types, chips and salsa, vegetable sticks and dips, and (one of my favorites) berry pie! On one memorable and very long air trip, my friend and I cooked an entire blueberry pie to eat on the airplane. We baked it, let it cool, wrapped it in a double layer of plastic wrap and put this wrapped pie back in its original box and then into our food bag. We had a couple of heavy-duty paper plates, plastic knives, forks and napkins. When we whipped out that pie during the trip there was not a traveler on the plane that was not envious and impressed. In fact, travelers commonly tell me that my food is far more attractive than what they are receiving from the food service on the plane. On return trips when I might not have access to a kitchen as I would at home, I still have my Superfood drinks (see Chapter 4) and I usually go for the cheese, mustard and crackers which are often available at snack bars, and even in the airport duty-free shops.

HINTS FOR USE WITH CHILDREN: Always let children know that you have plenty of snacks available for them on a trip and preferably let them taste-test some ahead of time. It is bad timing to try to change a child's snack preferences just as you start on a trip. Start introducing and experimenting with healthy snacks before your odyssey begins, taking them along

on jaunts to town for errands and for other short trips. On a trip, take a combination of new items and some that the child is more familiar with. One way to make healthy snacking more fun and attractive is to have a "snack pouch" for each child in which they can carry their own favorite snacks. This pouch can hang from a belt, or on a strap over the shoulder, or a string around the neck. Save the heavily-sugared and highly-processed snack foods they might be used to for a particular time and place during the day, but don't make them available all day long. The healthy snacks mentioned here can be eaten throughout the day to help your child maintain stamina, to balance their body chemistry and mood, and thus to limit their craving for junk food.

Travel Snack #1
Dried Fruits Mixed with Nuts and Seeds (often referred to as "Gorp," by those in the know).

This traditional mix can be had in some form just about anywhere in the world in grocery stores, open-air markets, and even at flea markets. I suggest always picking the ingredients yourself and mixing your own, avoiding the premixed varieties that are commonly made of inferior quality ingredients and handled in a questionable manner. Use raw, unroasted, unheated ingredients, and for the dried fruits try to always get the unsulfured varieties. These mixtures provide the perfect nutrient mix for long-lasting energy production: protein, fats, and sugars. Nuts that are oilier on their surface, such as macadamia nuts, go

rancid more easily than the less surface-oily types such as pecans and sunflower seeds. So, keep this in mind when determining a mix for travel. Apricots, dates, and figs make good additions to a travel mix but they are too big to mix conveniently with the smaller items like the raisins, crystallized ginger, dried berries, walnuts, pecans, pumpkin seeds, sunflower seeds, cashews and almonds. The solution is to get out your kitchen scissors and quickly cut up these larger dried fruits. Don't chop up your nuts and seeds, though. Chopping the nuts and seeds leaves many more surfaces exposed to the air and this promotes oxidation or rancidity. When you get your Gorp "formula" just how you want it, try to store it in a dark, cool and dry place—inside your daypack is perfect, but don't leave it in the window of the vehicle you are traveling in. Pint-size ziplock freezer bags (as opposed to the thinner plastic, sandwich bags) are a good container for these mixes, or any cloth pouch or leather pouch works well to hang from your belt.

HINT FOR USE WITH CHILDREN: Keep the mixture for children simple, using maybe six items. Many children and adults like the flavor of a little bee pollen mixed in (see Bee Pollen listing in Chapter 4). Try it in a small batch first so you don't end up with a flavor or texture your particular child does not like. It is a fun project to go shopping for possible Gorp items and let children chose how to customize a mix for themselves.

Travel Snack #2
Energy Bars / Nutrition Bars

Energy bars are a big business and there are currently so many choices in this category that it can get very confusing. You don't want to add to your junk food intake by inadvertently buying so-called "nutrition" or "energy" bars which contain little but empty calories, and worse. These things can actually make you sick and tired on your travels instead of energized and alert. Some of the better ones include (but are absolutely not limited to) Nutribiotic® *Prozone Nutrition Bar*, New Chapter® *Blood-Type Nutrition Bars* (but don't let the "eat for your blood type" thing stop you, just eat whatever variety appeals to you), and C.C. Pollen® *First Lady's Lunch Bar* and *President's Lunch Bar*. You won't find these in your local grocery store, so do make a trip to the health food store, or find them through the Internet, and order them before your trip.

HINTS FOR USE WITH CHILDREN: The three brands of energy/nutrition bars I suggested above have the added advantage of having at least a couple of flavors well-liked by children; especially the ones with pure chocolate. An alternative to an energy bar for children is a piece of whole-fruit "leather." These are flat, chewy slabs of pressed whole fruit. They are small, light and they store extremely well. Help your children have a healthy and mood-balanced trip by avoiding those unbalanced snack bars that are high in processed sugars.

What to Look For in an Energy / Nutrition Bar:

- **Whole foods and herbs**, including flash-dried or freeze-dried green juices and vegetable juices, unsulfured dried fruits, green and ripe papaya, nuts and seeds, bee pollen, herbal extracts, and *pure* chocolate (Yes!), preferably organic (definitely *not* the kind with processed fats and oils; see the What to Avoid list below).
- **Natural sweeteners** such as pure barley malt, date sugar, whole cane sugar, honey, maple syrup, rice syrup, and blackstrap molasses.
- **Organic ingredients if possible,** but often what you find is a mix of partly organic and partly not.
- **Healthy fats** for long-burning energy. For examples: *raw* coconut oil/butter, cold-pressed oils such as flax, sesame, olive and the natural fats found in nuts and seeds commonly included in nutrition bars.
- **Good balance** of proteins-fats-carbohydrates for an even energy output. For example, the first ingredient should not be a sweetener!
- **Protein source** is important. The best, in my opinion, are whey protein, brown rice protein, and egg protein.

What to Avoid in an Energy/Nutrition Bar:

- **Common fillers** should have a small part, if any, in the ingredients. In my opinion these include oats, soy, apple fiber, flax seed meal,

lecithin and rice powder (unless it is brown rice protein). These items do provide some health benefit, but they are not nearly as potent as some of the ingredients listed in the section above.

- **Processed sweeteners** should not be at the top of the ingredient list. Besides plain old sugar, watch out for all sorts of extra sweeteners being added under different names, like cane sugar, beet sugar, maltodextrin and corn syrup.

- **Synthetic sweeteners.** There is solid research (ignored but well publicized) regarding the poisons these sweeteners may contain (see *Safe Shoppers Bible* in the Bibliography). Some of the worst offenders are Aspartame (a.k.a. as NutraSweet® and Equal®), Saccharin, and any of the Cyclamates (commonly used in Canada and Europe). I am sure there are many sugar substitutes I have never heard of, so you are on your own to get smart about it.

- **Artificial flavors, colors, and additives.** Read the labels and if you don't recognize some of the ingredients, you probably don't want to eat it while traveling. Honestly, if I find a nutrition bar with some blue food color, along with something vague like "natural flavorings," I am going to be suspicious, and you should too.

- **Unhealthy fats** can predominate in nutrition bars that try to imitate candy. These con-

tribute to significant health troubles (see *10 Essential Foods*, and *Safe Shoppers Bible*, in the Bibliography). Avoid trans-, hydrogenated or partially hydrogenated and fractionated fats and oils. You will find that this eliminates many of the so-called health bars in the store!

- **Poorly balanced macronutrients**—proteins, fats and carbohydrates. If your ingredient list has many types of sugar and a filler or two listed first, and then halfway down the long list comes a hydrogenated fat coupled with a hint of greens or protein, this would be an example of an incredibly poor product that is depending upon the ignorance of the consumer for its sales. You can't afford to rely on such products for your travel stamina.
- **Poor protein sources.** This is a touchy category for health-minded folks. Because of my extensive research, I avoid any form of peanuts, soy, or milk as a protein source. There are so many better sources, listed above, that it isn't necessary to use these.

Travel Snack #3
Power Carob-Mint Spirulina tablets
These are a stamina producing mix that can be chewed up or swallowed as a tablet. They are made by the Pure Planet® Company and available at most health food stores. This mixture of carob, mint, spirulina and vitamin C, gives you all the good stuff of the spirulina algae Superfood (see details of

Algae in Chapter 4) along with the energy boosting sugars, minerals, other nutrients and great taste of the carob-mint combination. I carry these in a pouch, pocket, or small plastic container in my purse or backpack. That way they are available at the spur of the moment to keep me going. Perfect for those low blood sugar times when you know you are craving junk foods but you also know that if you go down that route you will soon be even more tired and run down with no lasting strength. You know the times: like when brain fatigue hits you at a meeting you have traveled halfway around the world to be at; or when you're stuck in a traffic jam of bicycle tongas in India, or a traffic jam on the way to work; when you're lagging behind on a mountainous trek and missing your planned meal stop; or when you're starting to get tired out walking about in that fascinating but enormous museum or art gallery, but you don't want to leave for a meal; or when jet lag sets in but you need to get going right away. These are perfect moments for this powerful snack.

When I don't care if my tongue gets a little green, I just pop two or three of those power tabs into my mouth and suck on them or chew them up and then drink some water. On the other hand there are just as many occasions when I simply swallow 10 or 20 with water, juice or something. There have been days when I have eaten them all day long and still felt great and energetic without a larger meal. Be sure to keep drinking water so the powerful nutrients can be transported to you cells.

HINT FOR USE WITH CHILDREN: Some children, especially if they are used to a healthy diet of whole foods, will go for these Carob-Mint tablets as a snack to suck on or chew. Additionally, you can crush the tablets and then dip a banana or other sweet fruit-bite into the resulting powder.

Once I took these Carob-Mint Spirulina tablets with me to a horse show. Throughout the day I just sat there sucking and chewing on them, not offering any to the children who had come along with me. They became curious as to what I was enjoying so much and I told them exactly what it was and that it was a flavor they might not be used to but they might like it. Five of them tried it and three of them asked for more. So, it's worth a try!

Travel Snack #4
Protein Drinks

Delicious protein drinks are made by mixing a prepared easy-to-digest powdered protein source with plain water or fruit juice, or as one ingredient in a fruit smoothie. Powdered protein products may come from vegetarian or non-vegetarian sources, such as milk, soy, brown rice, egg and whey. Some are flavored, and often the protein is part of a blended formula containing synergistic fats and sugars.

Protein powders and blends can be a satisfying meal replacement besides being a great snack. For those who don't want to be mixing anything up while

traveling, some products are also available in caplets or capsules. Two companies whose plain protein and protein drink blends (protein powder with a balance of healthy fat and sugar) I recommend are Nutribiotic® and Greens+®. For non-vegetarian protein I prefer whey protein; for vegetarian protein I prefer brown rice protein. If I am taking a protein powder with me on a trip I double-bag it in plastic zip-lock freezer baggies (quart-size). Also, I take a 16 oz. plastic cup with a tight-fitting lid for on-the-spot shaking/mixing of a fast pick-me-up protein drink snack. When cleverly coaxed, my baggie of protein powder fits inside the plastic cup (without its lid on) for efficient packing. Protein powders can also mix nicely with Superfoods for an even more powerful snack or meal-replacement. One company that mixes these two together, with several choices of flavor and protein sources for a good-tasting formula is *Greens+*®. Nutribiotic® makes great plain protein as well as a protein drink blend (*ProZone*®) containing the synergistic healthy fats and sugars. The list of what to look for and what to avoid for energy and nutrition bars applies to protein powders and blends as well. (Also see Superfoods, Chapter 4.)

TRAVEL BEVERAGES

See Chapter 2, Hydration is Life, for extensive coverage of beverages that are useful and necessary during travel.

SAYING YES! TO DESSERTS

Travel, in my opinion, should include a sampling of desserts from around the world. There is no problem in finding them, there is only the question of being discerning so you don't end up with the same synthetic, fake, sticky "goo" commonly sold in supermarkets as dessert. For myself, I love to try the local specialties while traveling, and I have also refined the pursuit. Unless I'm in a restaurant or at the home of a host, I buy dessert in a place where I can actually *see* the cook making the item in front of me. After all, that is part of my fun and not hard to find in the markets and fairs of every country. Great desserts include all types of fudge and chocolates, the amazing sweets from the street stalls of India, the maple sugar confections of Canada and the fresh ice creams of Germany and France where the milk and cream are more often not highly processed and full of chemical additives as they are in the U.S. In tropical countries, if you can find a vendor that practices a minimum of cleanliness in the process, fresh coconut milk and whole sugarcane juice are wonderful desserts. In remote areas especially in Third World countries, the trick is to always have your own cup with you and never use the vendor's cup. If sampling a confection on the street, don't use the plate and utensils that might be offered to the tourist, but go for it with your own napkin, utensil or hands.

I have many friends who adore ice cream and never pass up a chance to sample it wherever they

travel. While many travelers avoid desserts made with milk and cream on the general principle that these are high-contamination-risk items, especially off the "back streets," some people can't resist and for the most part come out okay.

Once after carefully watching a man making ice cream in a street stall in a remote village, and deciding that his methods were unusually hygien-ic, several friends bought a pint of ice cream each and proceeded to eat it—each in their own way. Some followed the example of most of the locals and simply squeezed their ice cream container and licked it off the top. Other friends pulled their own spoon from their pack and ate their ice cream straight from a paper container. One man accept-ed a bowl as well as a spoon from the vendor. No one in the bring-your-own-spoon or squeeze-from-the-container group got sick. The man who used both spoon and bowl from the vendor got so sick he had to have intravenous fluids administered for several days. Being an investigative type, I dug up information that might help clarify what had hap-pened that day. One of the witnesses told me later that she had seen the vendor offer a spoon to sev-eral of the locals and then wipe the spoon on his pants when they were finished with it. He then replaced it on a seldom-cleaned shelf where he kept the utensils for "special requests." The mice, rats and various insects would scurry around on that shelf, licking the spoons of leftover ice cream

*residues and then using them as resting spots. The
bowls came from a stack on the public counter
and were washed in a bin of cloudy cold water.
My witness was horrified to later see her friend
finishing his ice cream, spoon in hand (not to
mention the bowl). It was too late to do anything
about it so she didn't mention it and hoped for the
best. In this case her friend did survive, to the
tune of much teasing along the lines of "Let's go
get some more ice cream today!" So, the lesson
here is not that we need to avoid street vendors—
but to observe, observe, observe, before eating, eat-
ing, eating those desserts!*

FRESH, RAW, FRUITS AND VEGETABLES—The Real Power Source

In addition to growing my own fresh salad on the
road (see **Sprout It!** below), I love shopping in for-
eign countries for fruits and vegetables. Farmer's mar-
kets and open-air markets of some type can be found
almost anywhere in the world. In a well-stocked mar-
ket, one finds many items one can relatively safely
peel and eat. Luscious melons, nuts in the shell, corn
on the cob (lots of people love it raw), olives,
papayas, mangos, cucumbers, citrus, peas in the pod,
apples, bananas, carrots and pomegranate—to name
a few of the huge variety you'll find. I always peel and
sample unfamiliar fruits and vegetables of the coun-
try I am visiting—who knows when I'll ever get
another chance. Of course there are ways to deal safe-

ly with non-peel items such as in-season berries, and I'm about to get to that.

The only possible drawback in some circumstances is the possible air-born and earth-born contaminants that can come along with fresh veggies and fruits, like animal dung in places where cows and other farm animals are common companions on the street and where animal dung is used as a fuel source. I handle these problems in two easy ways. First, if I want to eat my purchases right away I only buy fruits or vegetables that I can peel before eating. Second, if I have the time and the place and the clean water, I soak other items with Grapefruit Seed Extract to detoxify them. (See Chapter 1 for details about GSE detoxification.)

Sprout It! For Fresh Salad Under Any *(almost)* Circumstance

Sprouted seeds hold a magnificent concentration of vitamins, minerals, proteins, enzymes, and fatty acids, which begin multiplying "like crazy" when a seed germinates. They make an excellent travel food. Many times during car travel, I have grown sprouts in a jar or baggie and then simply carried along a bottle of my favorite salad dressing for fresh salads every day. Sprouts, along with fresh fruits and some cooked whole grain (I use a small one-burner propane cooker for outdoors or an electric pot for hotels or campgrounds where there is electric power), have provided me with plentiful food at a price I could afford. Additionally I've been able to minimize my reliance

on poor quality restaurant food, saving my money for when I find a restaurant that has great food and *is* worth the price.

Basically there are two types of sprouts: 1. The type that are sprouted in about 5-10 days: the grower intends them to form a delicate, tender, chlorophyll-rich green leaf. These include alfalfa, radish and sunflower sprouts. They are usually grown upright for best results but I have also grown them in a tangled mass in a jar or baggie. They need some sunlight exposure to get green.

2. The type that are sprouted in about 3 to 6 days: the grower does not intend these to form a green leaf structure but rather a short sprouted "tail" perhaps up to 1/2 inch long. They do not need sunlight exposure to become edible. These second types are usually sprouted beans or grains such as wheat, lentils, flax, pinto beans, or hulled buckwheat, and are often grown in a jar, plastic container, or a natural-fiber cloth bag. (I use flax-cloth.)

Most seeds are traditionally grown one way or the other for best results. However there are some, such as buckwheat and wheat (two entirely different plants by the way) which can be grown as a short-tailed sprouted grain, or as a green leaf sprout.

For sprouting fresh food on the road, you *do* need a minimum of clean water but not as much as you might think. For the soaking and rinsing of my "salads" this was never a problem for me. I got very creative about using water frugally when I had very little and was using bottled water in foreign countries. On the

other hand, I stopped at parks all along the way while traveling across the U.S. and I used water generously. While on the move I have favored the growing of the #2 type of sprouts, because they sprout faster and are easier to maintain under any circumstance. However, on occasion I have done the #1 types in baskets on a car's rear dashboard, and RV-owners should have space to spare.

Once, traveling in India, I was feeling a little nutritionally deprived after a couple of months of backcountry fare in smaller villages. When I arrived in Pondicherry, a city on the southeastern coast, I had fantasies of sprouts filling my imagination, and headed straight for one of the fabulous open-air food markets. Soon, I stumbled into the stall of a dried-bean salesman and found what I was looking for. Lentils, the green kind many of us make lentil soup out of. What luck!

With my prize purchase in hand, I hurried off to find a room at one of the many inexpensive hostels near the ocean. On my way I bought a bottle of purified water for use in getting my sprouts started without delay. In my backpack I found a disposable plastic cup, battered but not yet leaking. I also pulled out of the depths of my pack one fairly new (surprise!) zip-lock baggie that I had brought from home. With these necessities I was ready.

Once settled in my room I filled the plastic cup one-third with lentils and two-thirds water,

and left the mixture to soak while I took off for the boardwalk along the ocean to see the sights.

The next morning I poured off the water that the lentils had soaked in overnight, rinsed the soaked lentils in as small an amount of fresh bottled water as necessary, then left the now plump lentils in their cup to start sprouting as I took off for the day's adventures. Meanwhile, each day I would never neglect to rinse, at least once and sometimes twice, my prized lentil sprouts that were popping open (sprouting). The lentils were sprouting so well, in fact, that on day two, after the initial overnight soaking, I transferred the sprouting lentils into the plastic baggie (which I left open so the sprouts could "breathe") to continue sprouting, while I started another small batch soaking in the plastic cup. In this way, by day three after the initial soaking, I had a good two handfuls of perfectly sprouted lentils—my idea of a fantastic power-snack, full of the nutrients I had been craving.

If sprouting sounds like it might be for you, get detailed instructions that can be easily adapted to travel from the source book *Sprouts The Miracle Food!* by Steve Meyerowitz. (See Bibliography.)

HINTS FOR USE WITH CHILDREN: Children prefer sprouts with a yummy dressing on them, so be prepared with one that your child likes. Yogurt and honey is generally a favorite, and these ingredients

are easy to put together with a short marketing stop almost anywhere in the world. Also, even if they don't want a salad, children might have fun growing them for *you* and get a kick out of watching you eat what they have provided.

RESTAURANT SURVIVAL

Eating out is part of the adventure and fun of travel. Searching for that special cuisine, ambiance, "food of the region," or magical fresh fish offered at a tiny oceanside stall—some people travel just for this! Once again, in addition to what I mention here, there are some detailed restaurant survival ideas in my book *10 Essential Foods*. The idea with ready-made foods is to get educated about where to look in the first place, and also have an idea of what you are looking *for*. It requires some conscious intention on your part to locate good, "clean" food. But, with minimal effort you will be greatly rewarded.

Many restaurants have a menu posted outside and this is good for travelers. Read a menu before you go inside, and especially check out the salads. You can tell a lot about a restaurant by looking at the ingredients of the salads. Are they primarily serving a pile of iceberg lettuce (sometimes politely called a "house salad"), or is the restaurant so proud of their salad that they actually name the varied greens and vegetables? A restaurant with a varied-greens salad can go a long way in supporting your travel strength.

Is there a salad bar? Go and look at it first. A salad bar should be predominantly fresh ingredients of great variety. Some will even include sprouts—a good sign and a cue that the restaurant is worth a try. Ask for *extra virgin* olive oil and lemon, if these are not obviously supplied, and mix your own salad dressing. Several times I have surprised even the waiter with this request because, even unbeknownst to the waiter, the chef in the kitchen had the items on hand for the rare customer who knows the difference. It is especially easy to find this wonderful oil at Italian and Greek restaurants. In this way you can lessen the "traveler's gut" that can result from the ingestion of highly-processed and liver-challenging vegetable oil mixes that are usually served as the standard fare in the salad dressing world. If what you see at a salad bar is mostly a mélange of processed foods such as canned peas, canned artichoke hearts, institutionally prepared pasta mixes and gelatin salads, canned black olives, and other such items, look elsewhere if you have the choice. If the salad bar is full of lifeless, processed foods, the rest of the menu is probably not far behind.

There is a difference between general restaurant eating while traveling and strategically going out for an exceptional meal. For fine dining with a first-class chef, the sky's the limit! But, for general restaurant eating while traveling or at a business luncheon, for example, you will get more nutrition, energy and stamina in exchange for the digestive demand, with

the simpler dishes —things you can still easily recognize even after they are prepared.

Try to avoid mixtures of several items cooked altogether and then camouflaged in sauce, especially heavy cream sauce. Avoid fried foods, breaded foods, and blackened meats. Limit your consumption of processed foods, and go for the items you know are being prepared fresh. Broiled or baked fish, poultry or meat, accompanied by a salad and a steamed vegetable are generally available, and serve as a good choice for a traveler who wants to maintain strength and balance. I suggest that you leave out the commonly offered "baked potato" or "pasta side dish" if you are eating fish or other meat. Eating lighter, you'll be preserving your digestive capacity for many more meals to come.

Other food combinations which make good digestive partners might include: pasta primavera; pizza topped with vegetables; beans or meat with rice and tortillas; and don't forget that a good fresh salad goes with everything. In fact, if the salads are looking fresh, lively and colorful, I often make that my whole meal, with a piece of special cheese on the side.

Always remember to bring along some cayenne or some digestive enzymes (see Chapter 1) to help your body process the meal.

Because I rely on a Superfood (see Chapter 4) mix for strength and energy as I travel, I take some with me into a restaurant. I ask for a large glass and order some bottled water to mix it with while I wait for my meal.

Ask if the drinking water served is just the local tap water and if it is, don't drink it. Order bottled water with a little lemon to squeeze into it, or hot tea or coffee. (See Chapter 2 about hydration, and Chapter 10 for information about the Steri-Pen® that can be elegantly used even in a restaurant if necessary.)

If I am trying to find a place to eat off the beaten track, which might happen anywhere from large modern cities to the lanes of remote villages where many wonderful foods are served by street vendors or in tiny cafés, I stroll around carefully watching the various cooks and their habits of cleanliness and care in food preparation. When I find a place that looks great, and if it proves out after a meal or two, I tend to keep going back to the same vendor. This makes them quite happy as well—a friendly arrangement that can be rewarding for a traveler who likes special care taken with his or her food, along with a very simple and affordable dining experience.

Consult the Internet resources (see Chapter 11) and get the names of restaurants that are noted for their healthy food in the area you will be traveling. There are also numerous guidebooks that can help you locate "health-conscious and eco-friendly lodgings," juice bars, health food restaurants, whole food/health food markets (which often have a great deli and/or café), and even raw food restaurants all over the world. (Especially noteworthy is *Viva's Healthy Dining Guide* by Lisa Margolin and Connie Dee, listed in the Bibliography.)

4.

SUPERFOODS
Power Fuel for Travel Stamina

Now here is a topic with increasingly wonderful choices, and an area I am endlessly experimenting with. Superfoods are those live, vegetarian *foods* with highly potent nutritional and rejuvenative qualities. A few of the generally healthy foods mentioned in Chapter 3 are also Superfoods, but most Superfoods are more concentrated and potent. They require little effort on the body's part to utilize; their power is almost instantly available to your system as soon as they are ingested. "A little goes a long way" with Superfoods!

Unlike many health supplements, Superfoods are not synthetic, nor are they made up of one singular nutrient that has been isolated and then concentrated. (These might have their place but are definitely *not* in the Superfood category.) The properties of Superfoods derive from components such as vitamins, minerals, amino acids, and the extraordinary

plant-based chemicals known as "phytochemicals" with their highly active antioxidant potential. The chlorophyll of green plants and the betacarotene associated with the orange pigmentation of carrots are two prime examples of phytochemicals/antioxidants.

Superfoods include but certainly are not limited to such items as specific herbs; particular seeds such as raw pumpkin seeds; bee pollen; royal jelly; medicinal mushrooms; fresh water algaes such as chlorella and salt water algaes (sea vegetables); and fresh or flash-dried vegetable and green juices. There are also extracts or concentrates of these Superfoods available—for example, fresh or flash-dried wheat grass juice, which is the juice without the fiber from the whole wheatgrass-Superfood.

Many of the items I will be introducing in this chapter may be entirely new to some readers and quite foreign to their current diet. But, because these foods are gaining such popularity so quickly, there will be lots of readers who have already started experimenting with Superfoods and are bragging to their curious friends about the great health benefits achieved. In any case, this book is for the health-conscious *"artiste* of travel" and I think some risk-taking in the Superfood's area is called for. Superfoods provide a huge payoff in strength, endurance and well-being for travelers, and are compact, lightweight, and easy to pack and store.

Health food stores and source books about Superfoods may apply this descriptor to single foods

—such as spirulina algae, fresh ginger, or bee pollen—or use it to refer to particular mixtures, such as *Perfect Food®* from the Garden of Life® company and others that I mention below. Those who learn more about Superfoods often buy their own separate ingredients to make customized mixtures.

I use various types of Superfoods daily, whether I am away from home or not. Almost everyday I make sure to mix up a "green drink" of one or two chlorophyll-rich fresh water algaes, or a more comprehensive Superfood blend such as *Pure Synergy™* from The Synergy company™. I mix my powdered Superfoods in a glass of distilled or purified water, but most friends use fruit or vegetable juice (apple juice or tomato juice are especially good for this and they are easy to find in most circumstances). At times when I need an extra boost while on-the-go, I might use a single Superfood item: suck on a piece of fresh ginger root, or eat a spoonful of bee pollen.

Once you get the idea of what Superfoods are, you will begin noticing many other choices at health food stores (ask for help here and you'll be shown) or other places where you shop. As you begin searching for and experimenting with Superfoods and their mixtures, be sure to read product labels and avoid those with product-diluting fillers such as processed sweeteners, synthetic additives, preservatives, single-item vitamins, non-essential fibers such as rice bran, etc. Every Superfood hunter will have her or his own favorites in terms of texture, ease of use, flavor, personal results with stamina and energy as well as

improvements in areas of special health needs. For example, if you have a high need for blood-sugar balancing, especially while traveling (maybe you have hypoglycemia or diabetes), the Superfood algae called chlorella is clinically proven to help this condition. Chlorella can be bought alone or as part of a mixture (some of the best is from the company Pure Plant®).

As you become educated through your own research you may even want to make a custom mixture, as I mentioned earlier. There are entire books written about the astounding properties of most of the Superfood items mentioned below. (See the Bibliography.) The idea is to use this basic introduction as a kick-start to your own experimentation before your next trip!

LALITHA'S FAVORITE SUPERFOODS

Here are some of my Superfood choices, chosen through years of experimenting. Check out the Buyer's Guide, Chapter 12, for additional sources for everything mentioned here, plus more.

SUPERFOOD #1: **Market-Fresh Raw Herbs**

Some of my favorites in this category are fresh garlic, fresh ginger root, and fresh or dried ripe spicy-hot cayenne-type peppers. (There are many types of hot peppers around the world but they all turn red if they are to be ripe.) Each of these items is available in

open-air markets and produce shops almost anywhere in the world. Add one or all of these wonderful raw herbs to your daily diet as you travel for amazing results.

Garlic, ginger and cayenne-type peppers are stimulating, stamina producing, illness preventing (with well proven anti-microbial and anti-inflammatory properties) and concentrated with unique phyto-chemicals, as well as the vitamins and minerals your body will love. Garlic and ginger are more potent in the fresh raw form, but it certainly doesn't hurt to have them cooked in a meal as well, or to drink the ginger in the form of tea or ginger ale.

Cayenne and other hot peppers, however, should never be cooked if you want the Superfood action they naturally hold. (When cooked, hot peppers such as cayenne become altogether different and quite caustic to delicate digestive membranes.) Since powdered cayenne pepper is part of my Smart Traveler's Health Kit, I always have it on hand in any case. (Refer to Chapter 1.) In different parts of the world the indigenous hot peppers come by different names and in varying degrees of "hotness." Eating a fresh ripe hot pepper (or garlic or ginger for that matter), or putting some of the cayenne powder in a liquid to drink, has kept me awake without resorting to caffeine, given me quick strength for extra brain-work at a meeting, warmed my body for that last bit of a frozen climb up a mountain, and saved me from the inconvenient aftereffects of many an overindulgence in food and drink.

SUPERFOOD #2: **Superfood Mixtures and Chlorophyll-Rich Algaes**

Superfood mixtures encompass a large variety of recipes containing high-potency ingredients such as chlorophyll-rich fresh and salt-water algaes, flax seed, deep green cereal grass juices such as barley grass or wheatgrass juice, medicinal mushrooms, herbs, bee pollen, flash-dried vegetable juice, royal jelly—to name a few.

Understanding a little about chlorophyll, the phytochemical responsible for the dark green color in plants (and knowing that Superfoods contain many such impressive phytochemicals), can be the inspiration you need to start "thinking green" and to begin using Superfoods right away. Knowing some details about fresh-water algaes, one of many outstanding ingredients in most Superfood mixtures, will give you a start on label-reading.

Chlorophyll stimulates the production of nucleic acids such as DNA and RNA, which are responsible for cell metabolism and renewal. Chlorophyll builds healthy hemoglobin in the blood, as well as being a significant detoxifier of all sorts of disease-causing microbes and environmental poisons. It is also a potent antibiotic. I can't imagine a more vital assist than chlorophyll-rich foods for the health of body and mind as you travel. There is a good deal written in my book *10 Essential Foods* about the incredible health benefits of chlorophyll. Superfood mixtures come in capsules, caplets, and bulk powders (which is mostly what I use).

Ounce for ounce, fresh water green algaes have more protein than red meat, and more vitamins—including B-12 and the rest of the B-complex—than other plant or animal foods. They contain major minerals, trace minerals, enzymes, essential fatty acids, potent antioxidants such as beta-carotene, copious amounts of phytochemicals and the highest concentration of chlorophyll of any plant. Being one-celled plants, when they are dried for sale they look like a fine green powder to the consumer, and they come in individual tablets or capsules and in bulk powder form.

Depending upon my travel circumstances I may use the tablets/capsules of a single algae, or bring along my bulk homemade algae mixture to add to water, juice or the room-temperature food I am eating. I use about 10 grams as one dose, which in most cases is 1 tablespoon of the bulk mix or about 20 of the usual 500 mg. tablets or capsules. My body weight is about 100 pounds and I eat from 1-3 doses of algae, or an algae mixture, a day. More than that is perfectly safe and a few of my larger-frame friends can easily handle 4 or more doses a day. You could live off of this food!

When using a powdered algae or mixture of algaes, I favor mixing it in tomato juice with a dash of red or black pepper. I usually dilute the tomato juice somewhat because without dilution the drink gets too thick for my taste. Although it makes an odd color, when I need to use a fruit juice I choose pineapple or apple.

Nowadays I have grown to like the taste and internal feel of my "green drink" so much that I often just mix it quickly in plain water, wherever I happen to be—in an airplane, hotel room, at a country picnic, or prior to a long meeting or other endurance activity. I wouldn't ever want to travel without my greens! When I can manage it, my "insider's trick" for extra *oomph* is to add a teaspoon or two of some healthy oil—such as extra virgin olive oil—to my drink. This provides me with a powerhouse fuel that can last most of the day. Knowing this trick comes in very handy on those long trips where you can't or don't want to stop for food. (Even though I really like this mixture, I have friends who tell me that this is not a flavor for beginners.)

If you want to make a bulk mix (you get lots more for your money this way but you will need to develop a taste for green as I have), try starting with 1 part spirulina, 1/4 part chlorella, and 1/8 part Klamath Blue Green.

Recommended Brands

See Buyer's Guide, Chapter 12, for ordering information. The list that follows are my favorite combination blends of algaes, green juices, herbal concentrates, medicinal mushrooms and flash-dried vegetable juices. They come in bulk powder, caplets, and in capsules.

- American Botanical Pharmacy® *Superfood*™
- Garden of Life® *Perfect Food*™
- Nature's First Law® *Nature's First Food*™

- New Chapter® *Host Defense*™
- Orange Peel Enterprises® *Greens+*™ and *Fiber-Greens+*™. *Greens+* is now offered on KLM airlines as part of their duty-free items.
- Pure Planet® *Power Carob-Mint Spirulina*™ (see Snack #3 in Chapter 3)
- The Synergy Company® *Pure Synergy*™

For **single algaes and simple green-juice concentrates** there are several high-quality brands. Look for:

- Earthrise®
- Green Foods Corporation®
- Klamath Blue-Green®
- New Chapter®
- Pure Planet®
- Source Naturals®
- Sun Chlorella®

HINT FOR USE WITH CHILDREN (AND "GREEN SHY" ADULTS): If children cannot swallow capsules or are hesitant to "drink green," start them on a small amount (perhaps 1/4 teaspoon) of a single-item fresh-water algae or Superfood mixture mixed in 4 to 6 ounces of tomato juice or a fruit juice such as pineapple, pear or apple. Also see Travel Snack #3 in Chapter 3, *Power Carob-Mint Spirulina*™.

SUPERFOOD #3: Bee Pollen

Nature's perfect food, bee pollen is the pollen of plants gathered up by the honeybee. The honeybee

then mixes the pure pollen with trace amounts of diluted honey and rolls this delicious mixture into tiny pellets. Bee pollen has other trace ingredients not yet identified—most researchers simply reference "a magic ingredient" since, in all the years that this substance has been studied, no laboratory has ever been able to fully identify and reproduce all the elements in the honeybee pollen pellets. Bee pollen is therefore not purely plant pollen, as many consumers believe. Since plants produce many colors and flavors of pollen, bee pollen too comes in a variety of colors and flavors.

It is well documented that bee pollen provides all the nutrients needed by humans for complete life support. It has a long history of use as an endurance and healing food for everyone from children to world-class athletes, and even for racehorses and sled dogs. Most people find the taste very pleasing, and except for the unusual case of a person with an allergy to bee pollen, it is enthusiastically received by all. I buy it in bulk and eat it just as it is by the small spoonful, or sprinkled on room-temperature foods. It is delicious sprinkled on ice cream!

HINT FOR USE WITH CHILDREN: It is easy to get children to eat bee pollen just as it is and it makes an excellent full-spectrum nutrient supplement for them in place of synthetic-nutrient tablets. Bee pollen is wonderful sprinkled on breakfast foods and can be made into "snack balls" by rolling it in a tiny amount of honey to produce a tasty morsel to pop into a child's mouth.

For traveling, each child should have her or his own small cloth "pollen pouch" attached to a belt or cord around the waist, or a decorative chain around the neck. That way the perfect food is only a lick away.

Recommended Sources: Verify that the bee pollen has been stored well-sealed, out of direct sunlight, and preferably in a dark, dry, cool place. Avoid buying the bee pollen displayed in the hot sun at outdoor vendors at flea markets, or in open-air markets. Ask the vendor to get you a product from their properly-stored inventory not on display. They will appreciate that you are a discerning customer! The best sources I know of for bee pollen are:

- Local beekeepers, who often sell direct, as well as through local health food stores
- C.C. Pollen® Company
- Mountain Big Sky®

5.

FOUR INCOMPARABLE TRAVEL TONICS

The dictionary defines "tonic" as an invigorating, refreshing or restorative agent or influence. Since the stresses and demands of travel wear us down, the health-wise traveler will greatly profit from a readily available tonic or two.

As far as I'm concerned, a good tonic is easy to prepare and pleasant to use (even daily), while it invigorates and stimulates optimal functioning of all bodily systems. I suppose some people might joke (I hope they are not serious) that they get the same results from caffeine, certain drugs, or a shot of alcohol. But these substances all have health-negative side effects. These are not the Incomparable Tonics we are talking about here!

A great tonic will:
- Gently and steadily help to clean, build and revitalize the blood
- Enhance digestive capacity
- Help to "package" toxins in the body for more efficient elimination
- Hasten recovery from the overindulgence of food and drink
- Increase the cell's capacity for proper hydration, intake of nutrients and cleansing of waste materials
- Enhance resistance to environmental pollution
- Strengthen the immune system
- Tone, firm, and clean the tissues of the body, including the internal organs
- Improve mental clarity and help overcome "brain fatigue."

This chapter, and the Four Incomparable Tonics presented below, will focus on three basic effects:

1. Helping the liver and gall bladder to function optimally and enhance their capacity for whole-body detoxification.
2. Helping the body maintain intake of electrolytes for hydration and proper acid-alkaline balance.
3. Helping the entire digestive system to maintain high digestive efficiency and to achieve enhanced "digestive recovery" in times of need.

Which Tonic(s) To Choose

Three of the Four Incomparable Tonics you can prepare for yourself, and one of them you have to purchase in advance from a health food store or through the Internet. Of course, while you *can* use all four of them (as I certainly have), you don't have to use all four to get the benefits I am going to describe for each one.

I would suggest starting with the one that seems most do-able for you, and add others if and when you feel to. Since a tonic is gently cleansing, it is always wise to start with one at a time to gauge what your individual response is going to be. The idea is to feel great, not to be having harsh cleansing reactions (temporary headache or aching, flu-like symptoms). However, if you *were* suffering from overindulgence in rich food or alcohol you would probably be feeling these same symptoms (headache, flu-like, etc.). If this is ever your situation, any of these Four Incomparable Tonics can actually *relieve* those symptoms.

INCOMPARABLE TONIC #1: Lemons are Your Liver's Best Friend

Your liver is a most powerful and amazing chemical factory, generally located just below and somewhat under the ribs, within the right front of the body. The liver has hundreds of jobs. It manufactures digestive "juices"—such as enzymes and bile—and

helps rid the blood of toxic substances like alcohol and other drugs, airborne and food-borne pollutants, including pesticides and the residues of microbes that cause food poisoning and other illness.

Your liver is a key organ in your immune system. If you keep it running well, your health while traveling will be a great asset instead of a big drag. When overworked, especially over years of rescuing us from our lifestyles, the liver easily becomes sluggish and less efficient in its functioning. Traveling, with its adjustments to change in diet, change in air and water, change in seasons, change in time zones, change in cultures and companions, even if it is to the paradise of our dreams, always adds extra work for the liver.

One of the simplest and most effective ways to help encourage your liver to decongest and achieve optimal functioning is with a fresh-squeezed Lemon Liver Tonic. Lemons (the yellow variety, as compared to the small green ones we sometimes call limes) have unique properties—organic acids, high concentrations of alkaline minerals, and their highly anionic (negatively charged) condition. These properties in lemons greatly enhance liver health and function, boost immunity, provide some antiviral action and help eliminate certain parasites. In fact, lemons are one of the most highly anionic foods there are, and this wonderful electrical capacity is an especially important and unique gift of lemon to the liver. [An "anion" is an ion with a negative electrical charge; it has a strong capacity for "building up," repair and

healing. A "cation" is a positively charged ion that has more of a "falling apart," decomposing or destructive effect. Even though both are needed and present in all life, cations are far more prevalent in our diets and lifestyles, while anions are almost non-existent in our diet, since they are destroyed with cooking and processing.]

But, remember to **use only fresh-squeezed lemon juice** to make this tonic. Do not use the lemon juice in the fake plastic lemons at the grocery store, nor the lemon flavoring used for cooking, nor any other substitute, like frozen lemonade.

The liver does a lot of work at night while you sleep, including repair work on itself. Just before sleep is a good time to drink a Lemon Liver Tonic. You'll wake up perky and bright.

For long trips I recommend taking one day a week as your "liver day." On your liver day, you eat as much as you want all day long of fresh fruits and vegetables or steamed/baked vegetables (not fried), but especially avoid any animal products and processed foods. Four to six times during the day, drink a Lemon Liver Tonic. I know people who have done this "fast" one-day-a-week for years and swear it has lessened the damage from their extensive business traveling.

My Lemon Liver Tonic recipe (see next page) is a fairly standard one recommended by many health and nutritional-food advocates. Feel free to adjust its strength and frequency of use according to your taste or response.

LEMON LIVER TONIC
4 Tablespoons (1/4 cup) fresh-squeezed lemon
juice
8 ounces pure water

Optional: 1 teaspoon or less of a natural sweet-
ener such as honey, maple syrup, or plain sugar.
Do not use synthetic sweeteners or sugar substi-
tutes of any kind for this tonic, as this defeats the
purpose and adds insult to injury upon the poor
liver.

EXAMPLES OF USE FOR LEMON LIVER TONIC:

Digestive distress: Use the Lemon Liver Tonic as a
fixer-upper for excessive use of food or alcohol, or
when you have eaten something that you now find to
be nearly indigestible. A good time to use it is an hour
or two before (where possible) and/or once or twice
"the day after" those occasions. As an **on-the-spot
digestive help**, for example in a restaurant, you can
always ask for some fresh lemon to squeeze into your
water, sipping this before, during and after a meal.

General Body-Systems Cleanser: Use it when you feel
your entire system is full of travel "sludge" or perhaps
the inklings of an illness are presenting themselves. It
is perfectly safe for most travelers to simply eat nothing
and drink the Lemon Liver Tonic alternated with plain

water all day long for a day or two. In this way you might drink up to a cup and a half of lemon juice (mixed in your tonics) distributed throughout the day. In addition to this you would also be drinking a minimum of 2 quarts (2 liters) of plain pure water. This gives your liver and all your body-systems a much needed rest.

Overindulgence recovery: For an entire day, stop eating solid foods except for fresh fruit or vegetables and stop drinking alcohol, sodas and caffeine. During this day use a tonic such as Lemon Liver Tonic, Honeygar Tonic (see below) or plain water. Do this type of healing diet for another day if you feel like it.

Caution: Some peoples' systems are over acidic with toxic acids, and so hypersensitive to any input—even the natural and mild organic acids of lemon. For these people I suggest diluting the Lemon Liver Tonic recipe as much as needed for it to be comfortable to the stomach and digestion. Start with as little as 1 teaspoon of lemon juice in 1 quart (liter) of water, buffered with a little sweetener as mentioned above, to sip during the day. Continue only if it is feeling good.

INCOMPARABLE TONIC #2: Honeygar
—Honey & Vinegar in Water

This tried-and-true folk remedy is easy to make and preserve in a concentrated form, so it can be

quickly ready for dilution in water as you need it on the road. You can even carry a small dropper bottle of it in your pocket or purse for use in restaurants, or store a larger amount in your car or in your backpack. You will probably love this tonic so much that you will want to keep it on hand at home to use daily.

Much has been written on the powerful health properties of "living," naturally-aged/fermented, undistilled, unpasteurized, apple cider vinegar (ACV) used alone and mixed with raw unheated honey, as it is in the Honeygar recipe below. Among the other qualities of apple cider vinegar, the most potent are its organic acids, enzymes, and high organic mineral content (especially potassium). Among the wonderful healing and rejuvenating qualities of the raw, unheated honey are its unique alkaline and nutritive qualities, honeybee-produced ingredients (including traces of bee pollen), and slow-burning sugars. (See the Bibliography for books about each of these ingredients.) These two powerhouse substances combine to give Honeygar the following fantastic tonic attributes:

1. Balancing blood sugar
2. Keeping a proper acid-alkaline synergy
3. Deliciously replacing the electrolytes lost in travel adventures of all sorts, whether you are mountain climbing, embroiled in business meetings, or coping with traffic jams.

Travelers need blood-sugar balancing, acid-alkaline synergy, and electrolyte replacement because the physical and mental demands of moving, eating and sleeping in new places and even the great excitement

of new adventures, easily uses up these resources on a daily basis. Every cell in your body depends on these resources for the "nutrients-in and wastes-out" cycle that results in energy, health, balanced body weight, tissue repair and vitality. The results of deficiencies of these resources may be **headache, foul mood, bad breath, apathy** and **lethargy, cravings** for junkfood and alcohol, and in general not feeling your best. In other words, the **"Traveler's Blahs."** So, let's make up a batch of Honeygar and get moving again!

*HONEYGAR RECIPE**
1 part pure, raw, organic, unheated honey
1 part raw, organic, naturally aged/fermented
Apple Cider Vinegar (ACV)

OPTIONAL for a more stimulating brew, add cayenne to taste.

DIRECTIONS: Mix 1 teaspoon or more (I often use 3-5 teaspoons) concentrate into 8 ounces of water. The water can be of any temperature you like from hot to iced. Just don't cook the Honeygar concentrate in the hot water. Add it after water is heated.

* Start with this proportion and then adjust it to your taste. Everyone's chemistry starts out differently and some of us like more honey or more ACV. For example, I use 1 part honey and 2 parts ACV for the concentrate. First-time users may want to start with the proportions given in the Hint for Use with Children, below.

Use only raw honey and unprocessed vinegar. If you can't get raw honey, you can substitute the best honey you can find. But, if you can't get live culture, naturally aged/fermented, unpasteurized ACV, it is best **not to use this tonic** rather than to go for the synthetic, pasteurized, distilled vinegar commonly available. "Real" ACV is actually alive with the cultures that naturally ferment it (as is yogurt, for example) and its acidity is balanced amongst its many healing qualities. Real ACV often has, or will quickly grow, a culture or "mother" visible at the bottom of the jar as a stringy-looking or brownish sediment, and in many cases the ACV can even be foggy-looking instead of clear. With unpasteurized ACV "foggy is good."

In the U.S. there are several brands of top quality unpasteurized, organic, ACV, available at health food stores, including: Bragg™; Eden Foods™; Hain™; and Spectrum Naturals™.

Outside of the U.S., look for ACV that is cloudy or translucent and still contains some of the "mother" as described above.

I usually mix up one cup of Honeygar concentrate at a time and keep it refrigerated, although while traveling I have often kept it unrefrigerated for a week or more without it spoiling. Once it is mixed with water, however, it will start spoiling quickly at warm temperatures.

When the concentrate is mixed with water it has a taste similar to lemonade. I like to mix mine really strong and so, as I noted above, I often put up to 3 to 5 teaspoons Honeygar concentrate into an 8-ounce

glass of water. However, to start with, I suggest using 1 or 2 teaspoons of honeygar in an 8-ounce glass of water. Mix the concentrate in proportions of honey and ACV that suit you, and then mix that concentrate with water at a dilution that tastes good to your particular taste buds. This is an indication that it is agreeable to your particular body chemistry of the moment. The way you like it will probably change over time and this is to be expected with the fluctuations in your body chemistry.

In the rare case that you are a person for whom even the smallest amount of vinegar is too acidic for your stomach, this is probably not the tonic for you.

EXAMPLES OF USE FOR HONEYGAR:

Appetite balancing: Drink a glass of Honeygar 30 minutes before a meal to give a boost to blood-sugar balancing ahead of time. Your appetite will then naturally be more in alignment with what you actually need to eat. People use this trick to both gain and lose weight.

Emotional stress: For mood and mind-body balancing prior to, during, and after emotional events, or ongoing tension or stress whether from internal or external causes, drink Honeygar regularly as you travel. You can keep a good mood even after an eighteen-hour flight! Honeygar can help balance upset moods such as **irritability**, **anger, overtiredness** and **hyperactivity in children**. If at the same time as using the

Honeygar for these symptoms, you also remove refined sugars from the diet, you will get even better, long-lasting results. This comes in handy when traveling with children whose diet has been heavy with sweets all day.

Menstrual cycle distress: Through the stimulation of the bodily systems and actions listed above, a glass or more of Honeygar can help with **PMS, tiredness**, and **menstrual cramping**.

Liver support: Honeygar will give your liver a boost and promote a mild liver decongesting action. Very handy when on a traveler's diet and after **overeating** or **alcohol use**.

Pancreatic strengthener: Honeygar's sugar-balancing properties can help recovery from the result of **too many sweets or desserts** on your vacation, relieve the **stress on the pancreas** (the body's primary sugar-balancing organ), and be a fine help for those experiencing chronic or temporary **low blood-sugar** for any reason.

Digestive aid: This tonic stimulates digestive juices and is fine to use before and after meals for this purpose. Helps your body assimilate nutrients and eliminate successfully. Helps relieve **stomachache** in children.

Overexposure to elements: Through quickly replacing electrolytes and balancing body chemistry, Honeygar

greatly increases stamina for and recovery from exposure to the elements whether it is intense **sun** and **wind**, or the deep **chill** of winter sports. Living in Arizona, I know many people who drink Honeygar throughout the day during the summer, and never get the **fatigue**, **headache** and feeling of **lethargy** associated with desert **heat**.

Hydration: Use this electrolyte drink for any condition requiring rehydration, like during a bout of **traveler's diarrhea**, **high fever**, or during an airplane trip where the atmosphere is notoriously dry. I have even given Honeygar to women during childbirth who tend to dehydrate quickly, and it did the trick.

Jet lag prevention and relief: In a small bottle, take Honeygar concentrate with you on the airplane. Mix it in water and drink it every hour or so during the flight. You will definitely have more trips to the toilet, but exercise is good for jet lag too.

Hangover remedy: Use Honeygar for relief of any type of hangover due to overindulgence—including too much alcohol, too much food, too much emotional drama, or all of the above. In 8 ozs. of pure water, I mix 2 to 3 tablespoons of Honeygar concentrate and at least 1/4 teaspoon of hot red pepper—the cayenne from your Smart Traveler's Health Kit would be the perfect thing for this. To wean off of an alcohol binge, the same recipe can be used as often as desired. For "alcohol recovery," or any other type of hangover, you

need electrolyte replacement, blood sugar balancing, and headache control. This Honeygar concoction will rebalance a disrupted body chemistry faster than anything I know of, leaving a fresh mood and a cleared head for renewed travel.

Immune system boost: During any illness you can gently cleanse the body of toxins and enhance healing processes by drinking Honeygar throughout the day.

HINT FOR USE WITH CHILDREN: Children often prefer more honey than vinegar in the base concentrate. I would start with at least equal parts honey to vinegar. For children who have high-sugar processed foods as a common part of their diet (such as sodas, candy, cakes, packaged breakfast cereals, etc.), I often start with twice as much honey as vinegar in the concentrate. Many times while traveling with groups of children, we have kept a jug of Honeygar already mixed up, ready to drink, in a beverage cooler. I believe it has helped a great deal in balancing the body chemistry and therefore the mood of emotionally upset or restless young travelers, and is great for children who are simply playing hard. Children often much prefer it cold or iced, not hot.

INCOMPARABLE TRAVEL TONIC #3: Pro Biotics

Pro Biotics is a catch-all name now used commonly in the health food and supplement industry. It

refers to the entire group of human-friendly (*Pro*) bacteria (*Biotics*) that thrive predominantly inside our digestive tract from the stomach throughout the intestines. In a mutually advantageous relationship, these bacteria live off nutrients within the human body, while at the same time providing substances that are absolutely essential to the body's well-being. It is not an exaggeration to say that our lives depend upon these friendly bacteria. When their colonies within us are compromised, so is our personal health. For example, although Pro Biotics are not limited to the intestines, anyone who has ever had diarrhea has experienced one of the many results from the disturbance of the proper balance of these friendly bacteria.

When the Pro Biotics (the friendly bacteria) are present in our digestive tract in sufficient numbers and varieties, this goes a long way in keeping out the unfriendly bacteria—the pathogenic and disease-provoking kinds—viruses, fungi, and parasites. This protective action is partly due to the fortunate fact that Pro Biotics can actually neutralize and destroy a wide range of pathogens, toxins or poisons. Travelers are regularly exposed to all sorts of additional pathogens that the body is not accustomed to encountering and handling. Therefore the smart traveler will be proactive in supporting and increasing the friendly bacteria that can protect not only digestive health but health in general.

Both Pro Biotics as well as pathogens enter the body primarily through the mouth. It is fairly simple

101

then, with a little planning, for a traveler to help the Pro Biotics to colonize while slowing down or eliminating the overgrowth of the pathogens. Through the foods we eat and through specific supplementation with Pro Biotics we can intentionally nurture the growth of these friendly bacteria.

How To Get Your Pro Biotics
I. Pro Biotic Foods

Using Pro Biotic foods during travel is actually quite simple, as *every* culture I have ever researched has fermented food products in their diet. Part of the fun is finding out what they are and sampling them wherever you go. Of course there are an endless variety of fermented alcoholic beverages, especially in the form of wonderful wines around the world, but the goldmine for traveler's health comes predominantly in the form of non-alcoholic Pro Biotics.

The most well-researched foods known to contain Pro Biotics and to nourish their growth are live-culture, naturally-fermented foods:

- Yogurt: Every country and many regions have their own varieties. Happy tasting!
- Miso
- Pickles. In the U.S. the word "pickle" refers to a marinated cucumber, period. When I visited France and requested a pickle, I was asked "What type?" as the word there refers to a large range of vegetables put through the pickling process.
- Sauerkraut

- Buttermilk
- Kefir
- Fresh whey from soured milk
- Undistilled naturally-aged Apple Cider Vinegar (see Honeygar Tonic)
- Kombucha tea (a potent, healing, fermented tea-brew, sometimes called Kvass; see Kombucha books in Bibliography).

Be a smart consumer and don't buy foods that started off fermented and full of live cultures to help you, but are then pasteurized (which kills all the friendly bacteria) supposedly "for your health."

In *The Life Bridge: The Way to Longevity with Pro Biotic Nutrients*, author Richard Sarnat, M.D. and others present an extensive listing of the fermented/Pro Biotic foods you can find around the world. (See Bibliography.)

A concentrated way to get potent doses of Pro Biotics is to buy and use a high-quality Pro Biotic supplement purchased at your health food store or via the Internet before traveling.

II. Pro Biotic Supplements

Health food stores will stock many potent Pro Biotic supplements. Some of them are formulated to handle changes of temperature and humidity (these are usually dry powders or tablets as compared to liquid form), and this is what a traveler would most likely want. Other Pro Biotics come in liquid or dry form, and must be kept refrigerated to keep the cultures alive and potent. A high quality product will be

clearly labeled as having live bacteria cultures. Avoid Pro Biotics that rely on artificial flavorings or processed or artificial sweeteners, especially if listed as a first ingredient.

Prices range greatly depending upon the quality or potency of the Pro Biotic supplement and whether it is just one strain of friendly bacteria or contains a fuller spectrum or variety of friendly bacteria. Experienced users of Pro Biotics will have a personal preference about which bacteria or mixture is the best for travelers. Including:

- *L. acidophilus*, a longstanding favorite of many travelers because of its action against parasites and stomachache. I prefer a capsule, tablet or powdered formulation which contains **several different bacterial strains** such as *Lactobacillus acidophilus, Bifidobacteria, Lactobacillus bulgaricus* and *Streptococcus themophilus* (the last two being important yogurt cultures).

- FOS: Pro Biotic formulations also often contain this special type of Superfood for the Pro Biotics themselves. FOS feeds and therefore enhances the survival of the friendly bacteria.

EXAMPLES OF USE OF PRO BIOTICS:

Digestion: Use daily as a powerful tonic to aid digestion, as an after-the-fact remedy, and to stop digestive problems before they take hold. Use Pro Biotics before and after you eat. Even when traveling extra light, many travelers swear that Pro Biotics are so

important that these are the only health remedy they take along. Digestive upsets of a huge variety such as **motion sickness**, **gas**, **burping**, **intestinal cramps**, **heartburn**, **indigestion** after eating, **loss of appetite**, and unusually strong food **cravings for sugar and animal products** (often symptoms of pathogens trying to take hold) can often be helped by Pro Biotic foods and supplements.

Constipation: Take double and triple doses of a Pro Biotic mixture, in between meals, 2 or more times a day.

Diarrhea: Take double and triple doses of a Pro Biotic mixture, in between meals, 2 or more times a day.

Upset stomach or stomachache: *L. acidophilus* is especially good for this.

HINTS FOR USE WITH CHILDREN: At least one company makes a good quality, good tasting, chewable *L. acidophilus* supplement. Several of my younger friends are almost instantly relieved of **motion sickness** and other **stomach upsets** when they suck on one of these chewable tablets (definitely not to be exchanged for other forms such as gummy-jelly types). They tell me the American Health® brand strawberry flavor chewable tablet is their favorite, and that berry and banana flavors are "yucky." These same young travelers have saved many a nauseated adult companion through sharing their stash of chewable-tablet Pro Biotics.

Many chewables are full of junky sweeteners, flavors, colors and non-viable cultures, so ask a knowledgeable health food store person for advice, and also see the Buyer's Guide, Chapter 12. However, a great many Pro Biotic supplements, in whatever form, taste quite good, especially if they contain the special food for Pro Biotics called FOS, which I mentioned above. FOS is naturally very sweet and tasty. If all you have are adult-variety non-flavored tablets, capsules or powders, it is definitely worth a try to have a child chew them, suck on them, or simply eat the powder from an open capsule. Or you can mix Pro Biotics with the child's room-temperature food.

Even infants can be given small amounts of Pro Biotics (read product label) and especially the *Bifidobacteria* which (should) naturally predominate in a child's healthy digestive tract.

INCOMPARABLE TRAVEL TONIC #4: The Ginger Aid

Ginger is a "stand-alone" tonic. Even though it can be creatively combined in all sorts of ways with other items, it really doesn't need any companions. Its major forms are as fresh (raw) Ginger Root, powdered Ginger Root, or concentrated Ginger Root supplement. As I prefer the fresh Ginger Root, I make it a point to buy a small chunk of the fresh root whenever I land in a new place. (I have found it even in the most obscure and hidden markets in small villages.) Then I

keep it in my pocket, backpack, or even my money belt. I want to have it ready at a moment's notice to gnaw on, suck on, and add to foods as I wander about. Now and then I even make it into tea by boiling it in water to taste. It is quite powerful as a warming drink.

There are entire books written on the extraordinary healing and rejuvenating properties of Ginger (see Bibliography). It is an antimicrobial, antiparasitic, digestive stimulant, circulation enhancer and stomach-soother . . . without equal. Alone or added to the other tonics in this chapter, it can give relief from overindulgence in food and drink. As a preventive for many travelers' ills, it is the one no-fuss, no-muss item I don't want to be without. You could call it a Superfood, a cure-all, a tonic, or a medicine and you wouldn't be wrong.

TYPES OF APPLICATION: With Ginger you can use it as much as needed until you get the results you desire. The only drawback for internal use is that in high amounts (depending on the individual) Ginger increases bowel activity. Externally, too much in the bath might feel uncomfortably warm. Rinse off with a cool shower and drink plenty of extra water.

Fresh Ginger Root: For myself I always prefer the fresh Ginger Root. As it stores almost indefinitely and almost never spoils, I keep a small chunk handy as I mentioned earlier—perhaps an inch or two. Then it is easy to suck on, or actually chew a bit (as I do). It is wonderfully spicy and stimulating so you may want to start with a tiny bit if you have never tried this before.

Powdered Ginger Root: For a dose of Ginger's health properties, you can always use 1/2 to 1 teaspoon of powdered Ginger Root mixed in 5-8 ounces of water; or put it in the Lemon or Honeygar Tonic and then swallow as a spicy "shot."

Ginger concentrate: You buy this at a health food or "bio" store or through the Internet before traveling. The highest quality I have found is made by New Chapter® and comes in many forms from their strongest concentrate called Zingiforce™, to several strengths of delicious ginger-honey syrup concentrates. Follow instructions on the label.

EXAMPLES OF USE FOR GINGER:

Cold hands, feet, or body: Use Ginger internally as suggested above, and externally you can soak hands, feet or whole body in a Ginger bath. For full bath, start with 1/4 cup Ginger powder in a full tub of warm water. Soak 20-40 minutes.

Constipation: Use Ginger internally as suggested in Applications above.

Flu-like symptoms: Use Ginger internally as suggested in Applications above.

Food poisoning: Use Ginger internally as suggested in Applications above.

Gas: Use Ginger internally as suggested in Applications above.

Headache: Use Ginger internally as suggested in Applications above.

Motion sickness: *T*o avoid motion sickness, try taking a dose of Ginger Root three hours before travel preferably on an empty stomach. You can continue taking doses as often as needed and they can even work after the fact (i.e., you are on a boat and all is well, but a storm comes up and then you get sick and that's when you take the Ginger).

Stomachache *(and all signs of indigestion):* Use Ginger internally as suggested in Applications above.

6.

EXERCISE IS KEY

If you are on a vacation trek through mountains or passing parks where you can stop and "play" while on a car trip, it's not a problem and you don't need to give exercise another thought. Survival exercises aren't necessary if your vacation includes swimming and snorkeling, skiing, days of leisure for tennis or golf and just running along the beach.

But for those of us stuck in some island paradise in the rain for days, or confined to a city hotel room with nothing but business meetings to look forward to for a week, or in transit for hours in cramped and public spaces, we definitely need to do more than "think" about exercise.

First of all, I am not talking about the "get-your-abs-in-perfect-shape-before-you-get-home-in-two-weeks" exercise binge. No. *Artistes* of travel" deserve exercise activities that will be models of cleverness, balance and forethought.

The types of exercise available to travelers are many and varied, and **the choices will be up to you.** Two things will carry you through, however, no matter what your circumstances:

1. That you have one, simple, indoor, no-equip-ment-necessary, **20-30 minute exercise pro-gram** planned and practiced, even briefly, before you leave. This might mean yoga pos-tures; Pilates® stretches; Canadian Airforce cal-isthenics; to name a few. (See Bibliography.)

2. That you bring along an **intention to exer-cise**, wherever you are and however it is pos-sible—like climbing stairs instead of taking the elevator. That intention will carry you through. You'll find that your intention will open up creative possibilities that you might never have dreamed of, and with fine results.

WORLD'S BEST TRAVEL EXERCISE

If there are two situations that modern travel is guaranteed to offer, they are **stress** and negotiating **cramped quarters**. Learning to exercise under either or both of these conditions is the key to staying healthy as you travel. No matter how stressful things become, or how tight your surroundings, if you mere-ly have enough room to take a deep breath, you will have all the space you need to uplevel your health. One or two full breaths can clear your head of **travel fatigue** and bring much needed relaxation and oxy-gen to every part of your body. Here's what to do:

1. Stop. Become aware of how your body is located in space: where your feet are, where your shoulders are, where your hands are, and so on.
2. Notice how you are breathing. Don't try to change it. Just be aware.
3. Notice if any part of your body feels tight. Gently bring your attention to that place, and say to yourself: "I am relaxing" as you inhale. "I am relaxing" as you exhale. Repeat 3 or 4 times, or more if you have time and attention.
4. Move your attention to another stressed place in your body and repeat #3.
5. Continue on your way.

WORLD'S SECOND BEST TRAVEL EXERCISE

Isometrics is a system of exercise that makes use of muscle contraction to strengthen and tone muscles. It is performed by the exertion of effort against resistance, usually of a stationary object. Sitting on the airplane, contracting your buttocks, thighs, and legs as your press your buttocks firmly against your seat and then slowly release the contraction—you are exercising! Such a simple thing, and yet it may mean all the difference between a stiff and painful back upon arrival, or a feeling of energy and renewal.

You can do isometric contractions and releases with any muscle group in your body, almost invisibly. Take it easy. Start slow. Enjoy the process.

7.

BEATING JET LAG

Jet lag is the temporary disruption of bodily rhythms caused by high-speed travel across several time zones. Your body is slowly and steadily attempting (too slowly for many of us) to reset its internal clock as it adjusts to new sun cycles at your destination.

The ideas presented in this chapter will help with any type of travel between time zones—be it by air, sea, or land. I will use the language of air travel since that is where the "lag" is most common, but it is certainly applicable to other modes of travel.

I start with offering you two essential methods for minimizing jet lag, and I strongly urge you to pick one and use it. Choose the one that best suits you. In addition, I've included a few other methods that may enhance your primary approach.

METHOD A: JET LAG PREVENTION

Keep *extremely* well hydrated. Don't skimp on this. One of the best preventives I know for jet lag due to a simple airplane trip, especially if under 12 hours (I have done this even for 18 to 20 hours), is to *not eat* during the trip at all and at the same time drink copious amounts of water (at least 2 liters). Part of the water intake (up to 1/2) could be through using either the Lemon Tonic or the Honeygar Tonic described in Chapter 5.

Drinking lots of water also allows you to increase your inflight exercise program, as you walk to the toilet more often.

But, even if you choose to eat, train yourself to drink at least 1 liter of water during the flight, and more for flights over 7 hours. (See Chapter 2 for more on this in general.) If not eating at all doesn't suit you, maybe Method B will.

METHOD B: JET LAG PREVENTION

Keep *extremely* well hydrated, as mentioned above, and don't eat *airplane* food. Period. (What you *can* eat, is coming up.) I know there are many systems of "jet lag help" that advise eating meals and to eat them timed with the meal times of the place you are going to. This advice is fine for the average traveler who is still expecting to show up tired, overstuffed, dehydrated and . . . yes, jet lagged . . . in spite of the perfectly timed meals. My advice is for the "*artiste* of travel"—the person who is not satisfied with feeling

in mediocre health or energy, just getting-by, but wants to be exquisitely well and energetic from the get-go. And this could be you!

Bring your own nourishment—favorite snacks (see Chapter 3), Superfoods (mix it with the fruit or tomato juice offered by the airlines; see Chapter 4), or home-prepared foods of your choosing. When you feel hungry, eat, but try to eat lightly. Eating lightly (this means stopping long before you get a full feeling) is a clever type of energy management that lessens the resources diverted to a digestive challenge (digestion is never optimal in the midst of the bodily upheaval of time zone changes in any case). Light eating leaves those resources available to produce more energy and attention to reorient your body clock, naturally detoxify, and feel great. After using the potent Superfoods and Tonics I describe in this book, if you still arrive a little hungry, it will be a sign of an alert and vigorous appetite that is the result of well-being.

If you are eating during a flight, the best timing would be at the time for meals according to your destination time zone. This gets your digestion going with the right timing.

ADDITIONAL IDEAS FOR JET LAG PREVENTION

The Vitamin C "Cure": Use only high quality, buffered, vitamin C—not the less expensive "ascorbic acid" form of vitamin C. In the amounts I suggest taking, the

ascorbic acid variety will most likely give you diarrhea. Read the vitamin C label and find forms such as calcium ascorbate, sodium ascorbate, or the ultra-buffered and wonderful Ester-C®. Starting 2 to 3 hours before your flight take 1 gram (1000 milligrams) of vitamin C along with 8 ounces of water, and then repeat this every 2 hours during the flight. In this way you may well take up to 10 grams or more during an extra long flight. If your flight is under 8 hours, go ahead and take 1 gram of vitamin C *every* hour if you like. After particularly grueling flights, you may want to continue using this vitamin C regimen at *half* (500 mg.) dosage 4-6 times a day, for another 2 or 3 days only.

The Sunlight Approach: Use sunlight to reset your body clock. I try to book my air travel seats to sit next to a window so I can take advantage of whatever sunlight is available, and it really helps. If you have a long layover somewhere, and the sun is shining outside the airport, check your luggage safely and leave the airport for a while, even if it means going through the Security Checks again. While in route, the sun starts your body regulating to the daylight hours of the place you are moving toward.

Upon your arrival, and if you are in an environment that warrants it, try to get out in the sun for at least an hour every day, starting immediately. If you are extra-sensitive to sunlight for any reason, be outside in the semi-shade.

Rising too early? You need more late-day sunlight exposure.

Trouble falling asleep? You need more early-morning sunlight exposure. However, I say take what you can get.

The Melatonin Method: Melatonin is a naturally-occurring brain chemical that regulates your natural body-clock (a.k.a. *Circadian rhythm*). Sunlight regulates Melatonin. In response to the signal of sunset, Melatonin is produced in the brain as a significant natural signal for rest. Plenty of current research shows that by supplementing with Melatonin at the proper time, it is possible to enhance your ability to reset your body clock quickly, thus minimizing jet lag.

For jet lag I have used a tiny dose (1/2 mg.) of Melatonin for years, and for me it works well. (See my personal Melatonin Plan on p. 118.) Depending upon whether you are flying east or west, many experts suggest an exacting timing for the use of Melatonin for days before, during, and after travel. It is very scientific and I would highly recommend it if it were easy, memorable and convenient—but I can never keep it straight. However, for myself I find that a simplified system works just as well. If "my" system shows promise for you but is not completely "it," you may benefit from slightly increasing your Melatonin dose from 1/2 mg. to 1 or 2 mg., or from investigating the more sophisticated scheduling written about, for example, in the book, *Blended Medicine the Best Choices in Healing* by Michael Castleman (see the Bibliography).

Lalitha's Melatonin Plan: The day before my flight I take a dose of .5 mg. (1/2 mg.) of Melatonin at the time corresponding to mid-evening (8 PM to 9 PM) at my destination. During the flight, I take another .5 mg. dose at the time corresponding to a mid-evening at my destination. I keep this up each day until I reach my destination. If I am stuck in a completely different time zone unexpectedly for several days, I have another plan. Either I stop taking Melatonin altogether, until I resume my trip, or I take it in the mid-evening *of the place I am in*. The day before I resume my trip I once again use Melatonin according to mid-evening of my destination.

But, as long as I am one-pointedly heading toward my destination—even if it will take a day or two but I am still progressing and not stuck anywhere—I keep taking this small dose of Melatonin at a time corresponding to mid-evening at my destination and I try to sleep within an hour or two of those doses of Melatonin if at all possible. As my body clock naturally resets, I may fall asleep on the flight. So, I tell my flight attendant not to wake me for meals. At my destination, for the first few nights until my body clock is fully adjusted, I may want to continue with a dose of Melatonin in the later evening, an hour or two before sleeping (perhaps between 9 PM and 10 PM).

Except, of course, in the instance of resetting your body-clock during an air flight as described above, Melatonin should *only* be taken at night during the times of the natural Melatonin release cycles which correspond to the day/night determined cycle of the sleeping hour. It should *not* be used as a "sleeping pill" just any old time you want to sleep during the day or wee hours of the morning.

Melatonin is available at health food stores in different forms and dosages (i.e., small tablet to swallow or sublingual tablet to suck on and varying strengths in milligrams) and this is where a little experimenting is needed. I use .5 to 1 mg. as my dose of choice, and in general a larger dose is not needed for most people although there are those who do use more. The common tablets come in dosages of 3 to 5 milligrams, but try to get a .5 to 1 mg. tablet as you can always add more later if you need to. (I have been known to end up buying the 1mg. tablet and then biting them approximately in half.) Probably the 3 to 5 mg. dose is most common simply because most people don't know that much less would work as well or better for the purpose of jet lag. When I take this higher dose it is definitely overkill and I wake up feeling a little groggy temporarily. This is why I suggest some personal experimentation before the trip might be in order. During nights while you are still at home, take one half to one milligram before you go to sleep and see how you feel when you wake up. The idea is to have deep, restful sleep from which you awaken feeling alert and refreshed. There are those with confirmed

sleep problems who suffer extreme jet lag and for these I have read research citing a dose up to 20 mg. If you are one of these extreme cases, your doctor should supervise your Melatonin use at these higher doses.

There are those who **should not use Melatonin,** such as pregnant or nursing moms and sometimes those with certain health problems such as depression, epilepsy, diabetes and more. Read the label warnings before using Melatonin.

The Caffeine Approach: If you can handle caffeine, some people find it useful to have a caffeine drink according to the "wake up" time of their destination. This can help tell your body clock that this is the new "morning" rhythm you need. But don't continue on with lots of caffeine, as this will leave you with an over-stimulated metabolism and not the strong and harmonious re-timing of your body clock. Just have the caffeine drink at the proper time for your destination circumstance and lay off of it after that.

Homeopathic Remedy: Many naturopaths and health food stores make available homeopathic remedies for jet lag. Many people swear by them and it might be worth a try for you. Homeopathy can also be a good choice for children.

Clean Air Assistance: If you do lots of air travel, it may be worth it to invest in a Mini-Mate ultra miniature Air Supply® manufactured by Wein® Products Inc. This "miniaturized corona discharge technology"

is a more technical way of describing an incredibly high output of negative ions—trillions per second to be exact—but without the electrostatic problems experienced with the negative ion generators of old. Great for jet lag, Seasonal Affective Disorder (SAD) (symptoms of sunlight deprivation and similar to jet lag—**fatigue, depression, lethargy, mental fog,** and **hypersomnia**—as can happen when traveling to climates with much less sunlight than you are used to), and a powerful air purifier for that questionable airplane and city air. (Read all about it in Chapter 10, Travel Gadgets.)

B Vitamin Rescue: To help reorient a confused circadian rhythm (body clock) and improve quality of sleep, use the form of vitamin B12 known as methylcobalamin. You can easily get this at health stores and it may be on the shelf of supplements next to the "regular" vitamin B12. This works especially well when used in combination with exposure to sunlight as methylcobalamin helps bright light do its job of stabilizing the internal body clock. Take 1 to 3 mg. of methylcobalamin in the morning. Start a few days prior to travel, use during time zone shifts, and continue for several days after you are settled in a time zone, or until you feel readjusted.

HINTS FOR USE WITH CHILDREN: My friend Zoë sends the following advice: "We have taken our two children to France every summer for the past five years to visit friends and have become very sophisticated in

our attempts to minimize jet lag and sleepless nights for them at our destination. We generally book a night flight and then allow them to sleep enough so that they are rested but little enough that they will be ready for bed at a reasonable hour at our destination. This has worked brilliantly but is a bit tricky. One time it completely back-fired because we had kept them from sleeping the last bit of the plane ride and during the three hour train ride only to have them fall asleep during the car ride one hour before we reached our destination. The net result was that they felt so refreshed upon arrival that they didn't go to bed until the wee hours of the morning.

If you are faced with a significant time change with a child, you may want to check with your naturopathic doctor for a children's homeopathic remedy. Homeopathy is easy to administer to children and certainly worth a try."

8.

PRE-TRIP HEALTH PLAN

It always pays off to plan ahead for a healthy trip by maximizing your strength and stamina ahead of time with a pre-trip health program. Then, upon return, you can do any damage-control required, or enhance your smooth reentry to your usual diet and schedule with a post-trip health plan.

10 DAY PREP

For at least 10 days to 2 weeks before starting a significant trip, begin the following, if you haven't gotten so inspired in reading the previous chapters that you are doing them already! This program also works well as a daily program while traveling.

1. Take one 125 mg. (approximately) daily dose of Grapefruit Seed Extract either as a tablet, capsule, or 12 drops of the liquid GSE in a little pineapple

123

or orange juice. **Children** follow the same procedure, although if using the 12 drops of liquid GSE, for children 6 years old and under it may be easier to take 2 doses of 6 drops each, twice during the day. For children under 2 years old, use one dose of 6 drops once a day in a bottle of pineapple or orange juice.

2. Begin taking an extra daily dose of your Superfood of choice, or start taking at least one dose if you haven't started already. **Children** may prefer a tablet or capsule form of Superfood, or mix 1 teaspoon Superfood powder in 6 ounces of a fruit juice such as apple, pineapple, or grape.

3. Use Pro Biotics two or more times a day. **Children** usually find this easy to eat in the powdered form.

4. Use the Lemon Liver Tonic or Honeygar, at least one glass every day and preferably twice. Why not one of each? **Children** usually want more sweetener for either of these Tonics and will more likely be drinking it in 4 ounce servings as often as they like to.

5. Assess your intake of water and make efforts to stay hydrated as I described in Chapter 2. Drinking a full quota of water daily can take some discipline and getting used to, so start now. To help **children** with this, get them an attractive water bottle and carrier belt so they can carry it around and use it. They might prefer herb tea or Honeygar in their water bottle but stay away from filling the bottle with juices. Juices are such

a concentrated, mood-altering and health-altering sugar it is better to not encourage a dependency on that for a primary liquid.

6. Begin a daily walking program if you haven't already, so you won't poop out and miss the sites. If you are planning to carry a load, some people find it helpful to walk with a gradually-weighted and balanced backpack, to help them adjust to the anticipated weight of their travel demand. The whole family can go on preparation walks, with or without their backpacks, and this will be a good reality check for what you can expect with your planned itinerary.

7. Choose an exercise form to use indoors, and begin to practice your daily routine for 20 minutes or more each day, as noted in Chapter 6.

8. Contact your doctor or health professional with any questions you may have about maintaining your health or that of your children as you travel. Order all your necessary prescriptions well in advance.

9. Study the websites suggested in Chapter 12. **Children** will enjoy looking at some of these sites and sometimes the older children might do the Internet surfing for you to find healthy places to eat and rest.

10. Order any health gadgets you may want to take with you, depending upon your individual needs.

11. Start to assemble your Smart Traveler's Health Kit. **Children** enjoy putting together the small containers of herbs and supplies.

12. Get plenty of sleep. Many travelers start off on a trip tired out from getting ready, or in the case of children "too excited to sleep." Two suggestions I have for this are to avoid keeping late night hours for the week before traveling, and each evening about an hour before sleep drink a cup of warm clove herb tea sweetened as desired with milk and honey. This goes for children as well as adults.

To Make Clove Tea: In one quart of water, boil 1/2 teaspoon whole cloves (easy to get at ordinary grocery stores and health stores) for about ten to fifteen minutes. Strain out the cloves. To the remaining tea add warm milk and honey to taste. Do not confuse this with the Clove essential oil that is in your health kit and which is *not* what to use for making this tea. Clove tea will help you relax and sleep so well that you will want to make this a habit whether you are traveling or not. See my book *10 Essential Herbs* for full details on the use of Clove as an herb for medicine and pleasure.

9.

POST-TRIP REENTRY

For at least a week to 10 days upon your return, use the five suggestions described below. These tips will help you to repair any health "damages" from your travel. Even if you are feeling great, the changes to your system upon reentry to your usual environment and schedule can be stressful. You can prevent any post-trip decline by paying attention to these health boosters now. If possible in planning your trip, try to arrive home a least two days before you must return to your usual work schedule. This is important.

POST-TRIP TIPS

1. Keep taking your daily dose of approximately 125 mg. Grapefruit Seed Extract for 10 days after your

return, even if you are feeling fine. Any pathogens encountered during the last days of your trip will thus be inhibited from growing. If you have any flu-like symptoms upon returning or soon thereafter, take this dose two or three times a day. If more post-trip health help is needed, also see GSE details in Chapter 1, Smart Traveler's Health Kit.

2. Drink at least two liters of water a day. This will help all your internal processes to cleanse, renew, and readjust to your usual environment.

3. Continue eating Superfoods indefinitely, but at least for one more week.

4. Use Pro Biotics for 10 days to two weeks more.

5. Now that you are home, take a full day to eat nothing but fresh (preferably raw or lightly steamed) fruits and vegetables, and gently cleanse your system by drinking at least 1 liter, and preferably 2, of the Lemon Liver Tonic as described in Chapter 5. The Lemon Liver Tonic will take the place of some or all of the plain water you drink.

10.

TRAVEL GADGETS

Most of the items listed here are available in travel stores, camping supply stores, and even some mass market stores such as Walmart and Kmart. Also, for most items there are some phone numbers and websites listed in the Buyer's Guide, Chapter 12.

EAR PROTECTION: There are two main things that a traveler's ears can need help with: **noise pollution** and the **ear pain** associated with the changes in cabin pressure while flying. For **noise**, I always take several pairs of disposable foam ear plugs made specifically to drastically cut down on sound input. These have been among my most valuable travel aids when I have been stuck in traffic jams with the constant blaring of horns, or trying to sleep in a noisy environment. With ear plugs, what might have been "an experience from hell" turns into a relatively peaceful time to read, sleep, or whatever. These are available at

most pharmacies in the U.S. and Europe. However, when trying to locate some at an Asian pharmacy, using what I thought was clever sign language, I have so far had no luck. Take a supply with you and you're all set.

For help with the **ear pain from cabin pressure** changes during air travel, disposable Earplanes® are a good way to go. These are a patented, pressure-regulating earplug. They also help dim the sound pollution in an airplane cabin, but not so much that you can't hear an announcement or someone speaking. They also come in a size for children, Children's EarPlanes®, so take some of each size for family air travel. Available in some U.S. pharmacies, or check the Internet and see the Buyer's Guide for more specific information.

10 ESSENTIAL HERBS™ HERB KIT: This is a kit of herbs, oils and tincture that prepares you for using all the healing ideas in my book *10 Essential Herbs* (see Bibliography). If a traveler knows all the ways to use these 10 essential herbs, then it will be easy to handle most health concerns whether at home or traveling, even if you don't have a Smart Traveler's Health Kit with you. A few of the items needed for the Smart Traveler's Health Kit are also included in this 10 Essential Herbs™ Herb Kit. It is put together carefully by hand by Rosalee Dodsen and is available from her via mail-order only, at ferguson@pa.net 800-542-5007, Fax: 717-248-4708. Books and kits are both available. See ad at end of this book.

MINI-MATE AIR SUPPLY™: If you do lots of air travel, it would be worth it to invest in a Mini-Mate ultra miniature Air Supply® model 150MM, manufactured by Wein® Products Inc. While not being simply a negative ion generator per se, this "advanced plasma discharge air purifier" puts out a huge amount of negative ions—trillions per second—but without the electrostatic and ozone problems experienced with the negative-ion generators of old. The high concentration of negative ions in the air with bright sunlight and after a rainstorm is what makes the air so potent and fresh. While super-charging the air through ionization, the Mini-Mate Air Supply™ also purifies the air of many types of **pollutants** including **tobacco smoke, animal dander, pollen, dust, odor particles, chemicals, bacteria, virus** and more. The manufacturer notes: "Preventing more than 85% of dangerous pollutants from being inhaled and killing close to 75% of many pathogens within two seconds of their entering the human breathing zone."

For travelers who chronically get **sick after air flight** because of the pathogens circulating in the air inside the plane, this technology could be dramatically helpful. Additionally, solid scientific research and testing have shown this device to be a powerful help for the **depression, hypersomnia**, and **fatigue** associated with **Seasonal Affective Disorder** (SAD). Since SAD has so much in common with jet lag, I tried this device for jet lag on an intercontinental flight. Wow! Now I don't travel without it. Not only did it send wonderful, purified, fresh-smelling air my

way for the entire trip, but my usual symptoms of jet lag were noticeably lessened.

Sometimes I leave it turned on near the head of my bed at night, particularly during intense travel. I notice better sleep and I wake up more refreshed.

Imagine my relief to have it with me when I was stuck for hours in a cloud of toxic fumes during a traffic jam in one of the most polluted cities in the world.

Wein® Products offers other sizes and forms of this technology for home and office, but for travelers this miniature version is the best choice. Worn around the neck, or attached to clothing, this device weighs in at an incredibly light 1.5 ounces, and runs almost silently for 60 hours of use on a lithium battery.

MOSQUITO REPELLING: Many travelers get great relief from mosquito attack by using Solar Mosquito Guard™. This is a key-chain size mosquito-repelling device that contains a miniature solar panel and is rechargeable by the sun. It emits a mild yet audible high-frequency wave that repels many mosquito species. No one really knows for sure why it works so well, but I have read that its hum mimics that of most male mosquitoes. The males are not the biters . . . or is it vice versa? Anyway, when the females hear this sound, they apparently try to escape, and thus do not come near you. This makes a good story, and in any case the Solar Mosquito Guard™ really works well for many. Although the slight sound might be bothersome to some, for those who are regularly attacked by

mosquitoes no matter what repellent they try, especially if those **bites swell up enormously and get infected** easily, the sound is far better than the bites. Luckily there is an on/off switch so you can use as needed.

To keep it going it must get some sun exposure to recharge. The battery recharges in three hours of sunlight.

MOTION SICKNESS: Acupressure works well for all types of **nausea** including the motion sickness encountered on all types of conveyances around the world. Naustrips™ are small, disposable, self-stick plastic strips that attach to the wrist and help relieve nausea associated with motion and morning sickness by non-invasively applying external pressure to a specific point at the inside of each wrist. This small pressure is achieved through a plastic or rubber "button" which you affix over the wrist point according to the simple instructions. I have also used a product similar to this, with the difference being that the plastic acupressure buttons are affixed inside a cloth wrist band. This particular one was called SeaBand™ and was purchased at an ordinary local pharmacy. I have seen this general idea under other brand names as well. The cloth wristband type are reusable. (See Naustrips™ in the Buyer's Guide.)

STERI-PEN®: The Steri-Pen®, manufactured by Hydro-Photon Inc., uses ultraviolet light to purify up to 16 ounces of water at a time. This miniaturized gadget is

proven to safely (to the user) destroy over 99.99% of **bacteria**, **viruses** and protozoa (microscopic **parasites**). These pathogens cause such diseases as **anthrax**, many types of **diarrhea, polio, hepatitis, food poisoning, typhoid, dysentery, cholera** and much more (the list of pathogens I read was quite long). The Steri-Pen® is hand held, weighs less than 8 ounces, is about the size of a small flashlight and uses four AA alkaline or lithium batteries to provide up to 130 UV purifying "zaps" (with the lithium) between battery changes and about 5,000 zaps between UV bulb changes. Of course it is smart to always purify the maximum amount of 16 ounces of water per zap, to get the most mileage out of your batteries. You can even get rechargeable batteries and battery chargers for international and domestic use.

Imagine being able to go anywhere there is water and being able to just take out this handy gadget and purify, for drinking, whatever water is available. In a restaurant serving tap water? In the woods for the day by a stream or lake? Cross-country train trip when the only water source is from the station's faucet? Get out your Steri-Pen®. The only caution I offer is to use it as invisibly as possibly in areas where, if you are making a scene with it, you might inspire it to be stolen. (See Water Purifiers and Filters, Chapter 12, Buyer's Guide.)

WATER FILTER: An alternative to a water *purifier*, is a travel-size water *filter*. A specialty back-packing store will be able to provide a very small, high efficiency water filter, which instead of killing pathogens, sim-

ply eliminates many of them through micro-filtration. Usually you pour water through it, pump water through it, or hook it up to a faucet you may find along the way. The smaller the micron measurement of the filtering technology, the more pathogens removed. For most removal of a broad range of pathogens, look for one that filters at least down to .4 microns. A travel water filter will usually remove some chemical residues and sediments, which the Steri-Pen®, for example, will not. Yet at the same time it is unusual to find a filter than can eliminate virus, as the Steri-Pen will. A good filter can cost less than $100 (U.S.) and commonly lasts through at least 500 gallons of filtering before needing a filter change. The trick with a filter is to confirm exactly what it is capable of filtering out of the water and compare this to where you will be most likely using the filter. There are some very good travel filters out there and worth checking into. (See Water Purifiers and Filters in the Buyer's Guide, Chapter 12.)

MORE GADGETS GALORE: These companies offer great travel supplies:
- Magellan's: 800-962-4943; www.magellans.com
- REI: 800-426-4840; www.rei.com
- Travel Smith: 800-950-1600; www.travelsmith.com
- Travel Oasis: 877-894-1960; www.traveloasis.com

11.

SURFING THE NET
FOR HEALTHY TRAVEL

**Traveler's "Green Guide" to Healthy Food,
Lodging, and More**

www.happycow.net A global directory of vegetarian restaurants and natural health food stores. This site is put together by travelers for travelers. The listings are quite extensive and are complete with address, phone number and a brief description. This site is user friendly and it is easy to submit your own comments, listings or corrections.

www.ecomall.com A website dedicated to promoting "green" or eco-conscious consumerism. Although not as slick as happycow.net, this site has quite extensive listings for restaurants in the USA. What may be listed on this site might not be on happycow.net and vice versa; they are both worth a look. For listings outside of the USA, I would stick to happycow.net. Although ecomall.com has some international listings, they are not as user friendly.

What I really like about this site is their search engine. Click on their local resource database and their search engine uses the yellow pages to find all listings under Grocers-Health; Health and Diet Food-Retail, or both. This provides a thorough listing for your chosen city. It will offer you searches in related topics such as Foods-Natural, Vegetables-Organic, and others such as wholesale and manufacturer listings of health, vitamin or homeopathic remedies.

www.vegdining.com This is a great site. Another global directory on vegetarian restaurants, this one lists vegetarian, vegetarian-friendly, vegan and vegan-friendly options in order to help find accommodating solutions for everyone's dining preference. Although there aren't as many listings as happy-cow.net on this site, vegdining.com goes the extra mile in offering more details on many of their listings such as types of cuisine, payment options, reservation info., directions, etc.

Many of the restaurants listed participate in the vegdining card program. Card carriers receive discounts on food and non-alcoholic beverages at participating venues around the world. The cost is $14.95 (U.S.) a year for one membership.

www.vegetarianusa.com Although not all the listings are as extensive as some other sites, it is worth taking a look at this site when planning your vacation through the USA. They offer listings of restaurants, natural food co-ops and health food stores with

addresses and phone numbers. They also have listings for alternative accommodations specializing in vegetarian B&Bs and spas, "new age" retreat centers and ashrams. Take a look at their travel guide.

www.vegeats.com A resource of resources. This site has links to all the vegetarian restaurant search engines and guides you could want. Just pick your place. Check out their link to Kate Pugh's Vegan Guide to the World. Many of the links on Kate's site are put together by individuals with their first hand experience. Worth a look.

www.veggieunderground.com Another great site with easy search for the city you're looking for. Hours, description, payment as well as addresses and phone numbers are available in quite a few listings. Not all cities are available, but it is a good adjunct to some of the bigger sites that may have missed some listings.

http://vegetarian.about.com Click on their Restaurants and Travel link on the side menu table for finding vegetarian restaurants, tours and accommodations world wide. Primarily good for links and listing references. The direct link to your state-specified travel guide at vegetarian USA is an easy, breezy way to get listings for accommodations, restaurants, co-ops, health food stores, books and gifts, spiritual centers and ashrams among many other sites of interest. **http://shamash.org/kosher** A global search database for kosher restaurants.

www.vrg.org Resource guide for the travelling vegetarian with accommodation links, restaurant links and links to vegetarian organizations with more links . . . don't get lost.

www.living-foods.com Their city guide concept is a great idea, offering people a resource guide to locating living and raw food resources in their local area or when travelling. Although there are just under 200 listings right now, look for this guide to take off and become a valuable resource for anybody looking to maintain "a natural way of living." Some of the resources listed are Farmer's Markets, Natural Foods Stores, Organic Produce Stands/Farms, etc. Under "Resources" there are restaurant listings that serve living and raw food. You can do your part in helping promote healthy raw food living by listing the resources in your area. It's easy to do.

They have bulletins, recipes, e-mails, and articles. Listings for books and magazines, health centers, educators and much more.

www.coopdirectory.org This is a great site with an extensive directory of natural food co-ops through out the USA as well as co-op distributors. They have tips on co-oping, links to alternative and whole food camps/accommodations, and links to many other great resources.

www.BetterOrganic.com "The best resource for everything organic and more! Inside this site you will

find farmers, growers, producers, wholesalers, retailers, franchises and Customers." Although most resources are U.K. oriented, this site has global ambitions and is definitely one to watch.

www.ecodirectory.com Although not the greatest reference site for travelers, limited listings for "eco-lodgings" are available.

BOOKS: Travel Guides to Order Via the Internet

www.earthfriendlyinns.com This is a promotional site for *Earth-Friendly Inns & Environmental Travel North East* by Dennis Dalhin. An environmental travel guide for the Northeast USA, this book has listings for farmers' markets and eco-shopping, places to buy organic produce, eco-hotels, "green" restaurants & cafes and so much more.

www.healthybelly.com This is the site sponsored by the Viva Center for Nutrition, publishers of *Viva's Healthy Dining Guide* by Lisa Margolin and Connie Dee. The site is constantly being updated to include worldwide sources. An up-to-date 2002 thorough eating-out guide for vegetarians and non-vegetarians wanting top quality, variety, and culinary adventure. Details on restaurants, markets, and more. The book covers only U.S., 350 pp., paperback. 866-612-2991.

www.travmed.com Travel Medicine Inc. is a catalogue of intriguing traveler's health supplies and is also a source for unusual items such as the oral rehydration packets prepared to the WHO standards. It can't hurt to have those packets along when on an extended trip to any out-of-the-way place. Email to travmed@ travmed.com, 413-584-0381 and 800-872-8622.

See end of Chapter 10 for great travel "stuff" catalogs.

OTHER TITLES OF INTEREST:

Artichoke Trail Travel Guide: A Guide to Vegetarian Restaurants, Organic Food Stores & Farmers Markets in the U.S. by James Bernard Frost. Hunter Publications, 2000.

The Tofu Tollbooth: A Guide to Natural Food Stores and Eating Spots with Lots of Other Cool Stops Along the Way by Elizabeth Zipern and Dar Williams, Ceres Press, 1998.

The Vegetarian Traveler: Where to Stay if You're Vegetarian, Vegan or Environmentally Sensitive by Jed Civic and Susan Civic, Larson Publications, 1997.

12.

BUYER'S GUIDE

Most of the items listed here are available at health food stores in the U.S.; some are available in Europe, and almost all can be obtained through the Internet. The contact information provided will enable you to get details on a product before purchasing it. I know that direct-mail or Internet ordering sometimes takes extra effort. However, take my word for it, these items are all worth the extra trouble.

General categories of products—like Digestive Enzymes or Energy Bars—are <u>underlined</u>, for ease of recognition. Single brand items—like Earplanes® or Mini-Mate Air Supply®—are not. Items are listed in alphabetical order in any case.

<u>BEE POLLEN:</u> See Chapter 4, Superfoods, for details. There are several good companies that carry bee products. What they should have in common is the extreme care necessary in collecting and preserving the pollen to keep it potent. One of the best compa-

nies I've found is C.C. Pollen, Phoenix, Arizona. 800-875-0096. **www.ccpollen.com**

DIGESTIVE ENZYMES: See Chapter 1, Smart Traveler's Health Kit, for details. Look for a plant-based digestive enzyme complex at most health food or "Bio" stores. Brands I have used and like are: Prevail: www.prevail.com; Rainbow Light: www.rainbow-light.com, 800-635-1233; and Source Naturals: **www.sourcenaturals.com;** 831-438-1144 and 800-815-2333.

EARPLANES®: See Chapter 10, Travel Gadgets, for details. Special ear plugs for air travel. Sizes for adults and children. Helps with ear pain due to air cabin pressure changes and also lessens sound stress. Commonly available at pharmacies and mass market stores such as Walmart and Kmart and can be also be ordered in the U.S. by calling 800-327-6151. **www.cirrushealthcare.com**

ENERGY BARS: See details in Chapter 3, Healthy Foods Everywhere. High quality nutrition bars are available from: New Chapter *Nutrition Bars,* **www.new-chapter.com**, 800-543-7279; C.C. Pollen *First Lady's Lunch Bar* and *President's Lunch Bar,* **www.ccpollen.com** 800-875-0096; Nutribiotic *Prozone Nutrition Bars,* **www.nutribiotic.com**, 800-225-4345.

GSE: Grapefruit Seed Extract. See details in Chapter 1, Smart Traveler's Health Kit.

Also known as *Citricidal®*, there are several brand names for this item and at least one, Nutribiotic®, is certified organic. It is available from most health food stores and from several sites on the Internet such as **www.nutribiotic.com**, 800-225-4345 and **www.nutriteam.com**, 800-388-0661.

10 ESSENTIAL HERBS™ HERB KIT: This kit of herbs prepares you for using all the healing ideas in my book *10 Essential Herbs* (see Bibliography). Several of the items needed for the Smart Traveler's Health Kit are also included in this 10 Essential Herbs™ Kit. It is put together carefully by hand by Rosalee Dodson and is available from her via mail-order only, at **ferguson@pa.net**, 800-542-5007. See ad at back.

MINI-MATE AIR SUPPLY®: See Chapter 10, Gadgets, for more details. A high efficiency, miniature air purifier. It costs less than $150. The best price I have found so far is from NutriTeam in Ripton, Vermont **www.nutriteam.com**, 802-388-0661. For scientific research data and to get help locating a retail source near to you, contact the Mini Mate Air Supply® manufacturer, Wein® Products, directly at 213-749-6049. Wein® Products is located in Los Angeles, CA. They have an informative website at **www.weinproducts.com**

PRO BIOTICS: See details in Chapter 5. Also see **Superfoods** listed below, to find mixes that include Pro Biotics in their formulation.
Great tasting brands include:

- American Health: Offers good quality preparations of the L. acidophilus bacteria in: *Acidophilus Chewable Strawberry*, and acidophilus bulk powder and capsules. The chewables come highly recommended by children and adults (See Pro Biotics in Chapter 5) and the plain product is fine as well.
- Prevail: *Inner Ecology*, good tasting bulk powder. Many children will eat it plain. A broad-spectrum Pro Biotic mixture including FOS, it is stabilized for traveling and does not have to be refrigerated. Distributed by Enzymatic Therapy, 800-783-2286, **www.prevail.com**
- Allergy Research Group: *SymBiotics w/FOS*, Great tasting bulk powder, most children love to eat it plain. A broad-spectrum Pro Biotic mixture including FOS. Ideally kept refrigerated. If not refrigerated it can last 1-2 days without losing much potency. **www.allergyresearchgroup.com**, 800-782-4274.
- Garden of Life: *Primal Defense*, small easy-to-swallow caplets and bulk powder. Broad spectrum of friendly bacteria including soil-based organisms, which can protect from parasite infestation as well as help eliminate them after infection. Extremely effective, but because of the soil-based organisms included, not as tasty as some of the other formulas (without soil-based organisms). No refrigeration needed. **www.gardenoflifeusa.com**, 800-622-8986.
- Also see **Superfoods** listed below, to find mixes that include Pro Biotics in their formulation.

SOLAR MOSQUITO GUARD™: See details in Chapter 10, Travel Gadgets. This is a solar battery mosquito repeller. Available from Gaiam Real Goods, **www.realgoods.com**, 800-762-7325.

SUPERFOODS: See details in Chapter 4. Check health food stores for other good products in addition to the suggestions below. Each company chooses a different mix of Superfoods for their formulation, so read the labels to get the ingredients you prefer. If you don't know what you like yet, you couldn't go wrong with any of these:

- American Botanical Pharmacy *Super Food*, a simple blend of wonderful whole-food Superfoods without any concentrates put together by Dr. Richard Schulze. **www.800herbdoc.com**, 800-437-2362.
- Klamath Blue Green *Klamath Blue Green Algae*, Bulk powder, tablets and capsules. **www.klamathbluegreen.com**, 800-327-1956.
- Garden of Life *Perfect Food*, a lively and unique blend of whole foods and their concentrates including green juices, flax, variety of vegetables and some Pro Biotics as well. A first class mix. Available at health stores in bulk and in caplets. **www.gardenoflifeuse.com**, 800-622-8986.
- Nature's First Law *Nature's First Food*. Exceptionally high-quality Superfoods complex including whole foods, juice concentrates, with an extraordinary Pro Biotics mixture included. Bulk powder form. Unusual to find this in a store but easy to

get through direct mail at **www.rawfood.com**, 888-729-3663.

- Nutricology® *Pro-Greens*. Bulk powder Superfoods complex that includes whole Superfoods, juice concentrates, herbs and Pro Biotics. 800-782-4274, **www.allergyresearchgroup.com**

- Orange Peel Enterprises *Greens+*, *Protein Greens+*, and *Fiber Greens+*, come in bulk powder and capsules. The basic *Greens+* product, contained in each product listed below, either as the sole ingredient or as part of the formula, is a full-spectrum mixture of whole Superfoods and concentrates of juices and herbs. The protein and fiber products have extras of those ingredients in them. The *Greens+* product is becoming readily available at many juice bars in U.S. and Canada. KLM Airlines even offers it as part of their duty-free sales during your flight with them. **www.greensplus.com**, 800-643-1210.

- Pure Planet, *Spirulina* algae and *chlorella* algae in bulk powder and tablets/capsules. Also Power Carob-Mint Spirulina™ (see Chapter 4, Superfoods), **www.pureplanet.com**, 800-695-2017.

- Synergy Company: *Pure Synergy, Vita Synergy* and *Klamath Blue Green Algae*. All are 100% organic. *Pure Synergy* is a broad-spectrum Superfood formula of potent foods/juices/herbs, Pro Biotics and more. Available in bulk powder and capsules. *Vita Synergy* is a full-spectrum, all natural food-based, vitamin-mineral-antioxidant tablet supplement. *Klamath Blue Green* algae can be purchased from

the Synergy company as well as other suppliers. You can only get the *Pure Synergy* and *Vita Synergy* items direct from the company or certain health practitioners. Call the company to order or to find a distributor near you. These products are the highest quality, without compromise. **www.synergy-co.com**, 800-723-0277.

WATER PURIFIERS AND FILTERS: Camping stores will often carry these items, although the Steri-Pen® is new and maybe easier to find online. All of these items can be found at **www.rei.com**, 800-426-4840, although the individual websites are probably more informative if you want research about them.

- **Steri-Pen®:** See Chapter 10, Travel Gadgets for details. UV hand-held water purifier, cost is $199 (U.S.), Hydro-Photon company, 207-374-5800. Located in Blue Hill, Maine, their website is quite informative **www.hydro-photon.com**.

- **Katadyn®:** See Chapter 10 for what to look for in a filter. Katadyn® is well known as a top-quality filter manufacturer, and they make several sizes and types for filtering different entities. Ceramic-filters as well as carbon-based filters are available, and prices start at about $90 (U.S.) for a mini ceramic filter, **www.katadyn.com**

- **PUR®:** See Chapter 10 for what to look for in a filter. PUR® is a fairly inexpensive and good quality carbon-based travel filter. **www.pur.com**

BIBLIOGRAPHY
For Healthy Travelers

Abrams, Karl, J., *Algae to the Rescue.* Studio City,
 Calif.: Logan House Publications, 1996, 191 pp.,
 paperback.
Banik, Dr. Allen E., *The Choice is Clear* [water as
 healer]. Austin, Texas: Acres USA, 1989, 48 pp.,
 paperback, www.acresusa.com.
Bartholomew, Alick and Mari, *Kombucha Tea for Your
 Health and Healing* [Pro Biotics]. Grawn,
 Michigan: Access Publishers Network, 1998, 183
 pp., paperback.
Bragg, Paul and Patricia, N.D., Ph.D., *Apple Cider
 Vinegar* [Honeygar info.]. Santa Barbara, Calif.:
 Health Science, revised 2002, 70 pp., paperback,
 www.bragg.com, 800-446-1990.
Castleman, Michael, *Blended Medicine the Best
 Choices in Healing.* Emmaus, Penn.: Rodale Press,
 2000, 708 pp., hardback, ww.rodalebooks.com,
 800-848-4735.

Chaitow, Leon and Trenev, Natasha, *Pro Biotics*. Hammersmith, London: Harper Collins Publishers (Thorsons imprint), 1990, 224 pp., paperback.

Diamond, Janet, *Exercises for Airplanes (and Other Confined Spaces)*[includes Isometrics]. Excaliber Publications, 1996, paperback.

Graci, Sam, *The Power of Superfoods*. Scarborough, Ontario, Canada: Prentice Hall, 1997, 291 pp., hardback.

Hobbs, Christopher, *Kombucha*. Santa Cruz, Calif.: Botanica Press, 1995, 56 pp., paperback.

Jarvis, DC, M.D., *Folk Medicine* [Honeygar information]. New York: Ballantine Books, 1992, 100 pp., paperback.

Margolin, Lisa & Dee, Connie, *Viva's Healthy Dining Guide.* Bridgewater, N.J.: Viva Center for Nutrition, 2002, 350 pp., paperback, www.healthybelly.com, 866-612-2991.

Meyerowitz, Steve, *Sprouts The Miracle Food!* Great Barrington, Mass.: The Sprout House Inc., 1997. 1-800-SPROUTS. Email Sprout@sproutman.com

Meyerowitz, Steve, *Water the Ultimate Cure*. ummertown, Tenn.: Book Publishing Company, 2000, 89 pp., paperback, www.bookpubco.com

Pure Planet Products, *Power Health with Spirulina.* Long Beach, Calif.: Pure Planet Products, 1997, 55 pp., paperback, www.pureplanet.com

Sachs D.S, C.C.N., Allan, *The Authoritative Guide to Grapefruit Seed Extract*. Mendocino, Calif.: Life

Rhythm, 1997, 125 pp., paperback, lisycee@mcn.org

Santillo, Humbart, *Food Enzymes the Missing Link to Radiant Health.* Prescott, Arizona: Hohm Press, 1987. 59 pp., paperback, www.hohmpress.com

Sarnat, Richard M.D., Schulick, and Newmark, Thomas M., *The Life Bridge: The Way to Longevity with Pro Biotic Nutrients.* Brattleboro, Vt.: Herbal Free Press, 2002, 159 pp., paperback, www.new-chapter.com

Schulick, Paul, *Ginger: Common Spice and Wonder Drug.* Prescott, Arizona: Hohm Press, 1996, 166 pp., paperback, www.hohmpress.com

Sharamon, Shalila and Baginski, Bodo J., *The Healing Power of Grapefruit Seed.* Twin Lakes, Wis.: Lotus Light Publications, 1996, 150 pp., paperback.

Siler, Brooke, *The Pilates® Body.* New York: Broadway Books, 2000, 193 pp., paperback.

Steinman, David and Epstein M.D., Samuel, *Safe Shoppers Bible.* New York: MacMillan, 1995, 445 pp., paperback.

Thomas, Lalitha, *10 Essential Herbs.* Prescott, Arizona: Hohm Press, 1996, 369 pp., paperback, www.hohmpress.com

Thomas, Lalitha, *10 Essential Foods.* Prescott, Arizona: Hohm Press, 1997, 309 pp., paperback, www.hohmpress.com

10 ESSENTIAL HERBS, REVISED EDITION
by Lalitha Thomas

Peppermint. . .Garlic. . .Ginger. . .Cayenne. . .Clove. . . and 5 other everyday herbs win the author's vote as the "Top 10" most versatile and effective herbal applications for hundreds of health and beauty needs. *Ten Essential Herbs* offers fascinating stories and easy, step-by-step direction for both beginners and seasoned herbalists. Learn how to use cayenne for headaches, how to make a facial scrub with ginger, how to calm motion sickness and other stomach distress with peppermint. Special sections in each chapter explain the application of these herbs with children and pets too. Over 25,000 copies in print.

Paper, 395 pages, $16.95, ISBN: 0-934252-48-3

10 ESSENTIAL FOODS
by Lalitha Thomas

Carrots, broccoli, almonds, grapefruit and six other miracle foods will enhance your health when used regularly and wisely. Lalitha gives in-depth nutritional information plus flamboyant and good-humored stories about these foods, based on her years of health and nutrition counseling. Each chapter contains easy and delicious recipes, tips for feeding kids and helpful hints for managing your food dollar. A bonus section supports the use of 10 Essential Snacks.

Paper, 300 pages, $16.95, ISBN: 0-934252-74-2

NATURAL HEALING WITH HERBS

by Humbart "Smokey" Santillo, N.D.

Foreword by Robert S. Mendelsohn, M.D.

Dr. Santillo's first book, and Hohm Press' long-standing bestseller, is a classic handbook on herbal and naturo-pathic treatment. Acclaimed as the most comprehensive work of its kind, *Natural Healing With Herbs* details (in layperson's terms) the properties and uses of 120 of the most common herbs and lists comprehensive therapies for more than 140 common ailments. All in alphabetical order for quick reference. Over 150,000 copies in print.

Paper, 408 pages, $16.95, ISBN: 0-934252-08-4

FOOD ENZYMES: THE MISSING LINK TO RADIANT HEALTH

by Humbart "Smokey" Santillo, N.D.

Santillo's breakthrough book presents the most current research in this field, and encourages simple, straightfor-ward steps for how to make enzyme supplementation a natural addition to a nutrition-conscious lifestyle. Special sections on: • Longevity and disease • The value of raw food and juicing • Detoxification • Prevention of allergies and candida • Sports and nutrition.

Over 250,000 copies in print.

Paper, 108 pages, U.S. $7.95, ISBN: 0-934252-40-8

(Spanish version also available)

Audio version of Food Enzymes

2 cassette tapes, 150 minutes, U.S. $17.95,

ISBN: 0-934252-29-7

BEYOND ASPIRIN: Nature's Challenge To Arthritis, Cancer & Alzheimer's Disease
by Thomas A. Newmark and Paul Schulick

A reader-friendly guide to one of the most remarkable medical breakthroughs of our times. Research shows that inhibition of the COX-2 enzyme significantly reduces the inflammation that is currently linked with arthritis, colon and other cancers, and Alzheimer's disease. Challenging the conventional pharmaceutical "silver-bullet" approach, this book pleads a convincing case for the safe and effective use of the COX-2-inhibiting herbs, including green tea, rosemary, basil, ginger, turmeric and others.

Paper, 340 pages, $14.95, ISBN: 0-934252-82-3
Cloth, 340 pages, $24.95, ISBN: 1-890772-01-1

GINGER: Common Spice & Wonder Drug (Third Edition)
by Paul Schulick

Author Paul Schulick calls ginger "the universal medicine." His book surveys the ancient claims of ginger's effective health usage as these are verified by international medical research. Supported by hundreds of scientific studies, this book leads the reader to discover the extraordinary personal and social benefits of using ginger.

"A wonderful collection of information. A convincing case." —Andrew Weil, M.D., best-selling author of *Spontaneous Healing*

Paper, 176 pages, $9.95, ISBN: 1-890772-07-0

— Retail Order Form For Hohm Press Books —

Name _____ Phone () _____

Street Address or P.O. Box _____

City _____ State _____ Zip Code _____

QTY	TITLE	ITEM PRICE	TOTAL PRICE
	10 ESSENTIAL HERBS	$16.95	
	10 ESSENTIAL FOODS	$16.95	
	NATURAL HEALING WITH HERBS	$16.95	
	FOOD ENZYMES (ENGLISH)	$7.95	
	FOOD ENZYMES (SPANISH)	$6.95	
	FOOD ENZYMES (AUDIO)	$17.95	
	BEYOND ASPIRIN (PAPER)	$14.95	
	BEYOND ASPIRIN (CLOTH)	$24.95	
	GINGER	$9.95	
	TRAVEL HEALTHY	$9.95	

SURFACE SHIPPING CHARGES:

1st book...$5.00

Each additional item.....................add $1.00

SUBTOTAL: _____

SHIPPING: _____
(see below)

TOTAL: _____

SHIP MY ORDER:

☐ Surface U.S. Mail—Priority ☐ Fex-Ex Ground (Mail + $3.00)

☐ 2nd Day Air (Mail + $5.00) ☐ Next Day Air (Mail + $15.00)

METHOD OF PAYMENT:

☐ Check or M.O. Payable to Hohm Press, P.O. Box 2501, Prescott, AZ 86302

☐ Call 1-800-381-2700 to place your credit card order

☐ Or call 1-928-717-1779 to fax your credit card order

☐ Information for Visa/MasterCard/American Express order only:

Card#_____-_____-_____-_____ Expiration Date: _____

Visit our Website to view our complete catalog: www.hohmpress.com
ORDER NOW! Call 1-800-381-2700 or fax your order to 1-928-717-1779
(Remember to include your credit card information.)

10 ESSENTIAL HERB KIT

Formulated by Lalitha Thomas

Prepared and sold by **Thyme To Get Healthy**

A unique herb kit–the only one you'll ever need for first aid, travel and home health. Kit comes in a colorful storage box and is packed with generous amounts of high-quality herbs, oils, and tincture, including:

- Cayenne powder
- Chaparral
- Clove buds
- Clove powder
- Clove oil
- Comfrey leaf
- Comfrey root powder
- Echinacea purpurea powder
- Echinacea tincture

- Garlic powder
- Ginger powder
- People Paste (slippery elm, myrrh, barberry, goldenseal)
- Peppermint leaves
- Peppermint oil
- Slippery Elm powder
- Yarrow blossoms

COMPLETE KIT ..*$45.00*
KIT PLUS BOOK (10 Essential Herbs, Hohm Press, 1995)*$62.00*

Prices include First-class Postage

Send check or money order in U.S. funds
(outside United States, add 25%) to:

Thyme to Get Healthy
12466 Ferguson Valley Road
Lewistown, PA 17044

Or place order by:
email: ferguson@pa.net
phone 800-542-5007
fax: 717-248-4708
VISA & MASTERCARD ACCEPTED

SYMPTOM-REMEDY INDEX

A

Acid indigestion – 13 (see also Digestion, Heartburn)

Allergic symptoms – 37

Anger – 97

Animal dander – 131

Anthrax – 134

Antimicrobial – 6, 14, 20, 26, 31, 107

Antiparasitic – (see Parasites)

Antiviral – (see Viruses)

Antiseptic – 5, 6, 8, 26 (see also Disinfect, Bacteria, Viruses)

Anti-inflammatory – 11, herbs 80

Appetite problems – balancing 97, loss of 105

B

Bacteria – 14, GSE 20, Salt 31 & 34, 36, 38, water purifying 45, friendly 101, airborne 131

Back pain – (refer to Chapter 6 – Exercise)

Bad breath – 95

Bleeding – external, internal, ulcers 21

Blisters – 27 (see also Skin Ailments)

Blood – blood sugar 62, 79, 94, 98; build, clean, revitalize see Travel Tonics, 87

Breathing problems – see Respiratory congestion, Allergic symptoms

Bug bites – 9, 11, 27

Bug repellant – 8, 132

Burping – 105

C

Caffeine – habit breaker 23, substitute 25, 93, jet lag 120

Chapped lips – 27

Children – refer to same adult symptoms

Circulation – 23, 107

Cold hands and feet – see **Circulation**

Congestion – nasal and respiratory 9, 28 (see also **Nasal distress**)

Constipation – 24, 28, 105, 108

Cramps – 41, intestinal 105, menstrual 98

Cravings – caffeine 23; junk food, alcohol, 95; sugar, animal products 105

D

Decongestion – liver 98, (see also **Congestion, Respiratory congestion**)

Depression – 28, 41, Seasonal Affective Disorder 121

Detoxification – superfoods 81, 88

Diarrhea – 11, 12-14, prevention 19, 99, 105

Digestion problems – 9, 13, 23-4, 29, 36, 104, 109

Disinfect – anything 19; food and water 17-19, 47

Dust – 131

Dry Nose – 27 (see also **Nasal distress**)

Dysentery – 134 (see also **Diarrhea**)

E

Ear pain – 6, from cabin pressure 129

Energy – snacks 53, 95, 112

F

Fatigue – tiredness 28, 97; hydration 41, from alcohol 49, Honeygar 99, 111, 121 (see also **Mental fatigue, Lethargy**)

Fever – 11, 99

Flu-like symptoms – 34, 89, 108, 128

Food disinfection and preparation – see **Disinfect**

Food poisoning – 11, children 14, 17, 108

Frostbite – 24, 39, 50

Fungi – food cleaning 34, in water 45, 101

G

Gall bladder – tonic 88

Gas – 36, 105, 109 (see also **Digestive problems**)

Gargle – see **Sore throat**

H

Hangover – 25, 49, remedy 99 (see also **Overindulgence**)

Headache – 9, 25, 28, dehydration 41, 95, 109

Heart attack – 23, 25

Heartburn – 11, acid indigestion 13, 105

159

Heart tonic – circulation 23

Heat prostration – see Overexposure

Hepatitis – 134 (see also Liver tonics)

Hives – 11 (see also Skin ailments)

Hyperactivity in children – 97

Hypersomnia – see Sleep disorders

I

Immunity – strengthen 88, lemon 90, boost 100

Indigestion – see Digestion problems

Insect bites – see Bug bites

Insect repellant – see Bug repellant

Infections – 13, earlobes 16, external 20 (see also Antimicrobial, Disinfect, Parasites, Virus)

Inflammation – 11, 80 (see also Fever, Flu-like symptoms, Skin ailments)

Intestinal problems – 13, 24, pro biotics 104 (see also Constipation, Diarrhea, Digestive problems)

Irritability – 97 (see also Moods)

J

Jet Lag – 25, 62, Honeygar 99, 113-122

L

Laxative – 27 (see also Constipation)

Lethargy – Honeygar 95, 121 (see also Fatigue)

Liver tonics – 88, 89, lemon 92, Honeygar 98

M

Mental fatigue – 62, 88 (see also Fatigue)

Menstrual distress – 98

Moods – 41, alcohol 49, 56, children 58, Honeygar 95, 97, 125 (see also Anger, Fatigue, Irritability)

Motion sickness – peppermint 9, 105, ginger 109, 133 (see also Nausea, Stomach problems)

Muscle ache – 41

N

Nasal distress – congestion 9, dry nose (inside) 27, 29, rinse 32

Nausea – 8, 39 (see also Motion sickness, Stomach problems)

Noise Pollution – 129

Nose problems – see Nasal distress

Nutrition – xii, 10, 12 (refer also to Chapter 3 - Healthy Foods Everywhere, and Chapter 4 - Superfoods)

O

Odors – 131

Overindulgence in food or drink – xiv, 80, 88, Honeygar 93, ginger 107 (see also **Hangover, Digestion problems**)

Overexposure – 24, 39, heat 50, 98 (see also **Heat prostration, Frostbite**)

P

Pain – internal 11, external 7, 11; exercise 112, clove tea 126 (see also **Ear pain, Toothache**)

Parasites – internal and external 20, 31-32; 38, water purifying 45; 90, acidophilus 104

Pimples – 27 (see also **Skin ailments**)

Polio – 124

Pollen – plant pollen 36, 131; bee pollen 58, 77; superfood 84

Pollution – effects of 81

R

Respiratory congestion – 9, 35

S

Seasonal Affective Disorder (SAD) – 121, 131

Sleep disturbances – 117, 126, 129 (see also **Jet Lag**)

Shock – 22, 25, 26, 39

Skin ailments – blemishes 28, blisters 26, infection 20, 31; irritation 7, pimples 27, rashes 11, sunburn 27, 39, 50; windburn 27

Sore throat – 6-7, 21, 31

Sprains – see **Strains**

Stamina – 56, 61, 76-86, Honeygar 99, 123

Stiffness – 112

Stress – 97, 111 (see also **Fatigue, Moods,** and refer to Chapter 4 – Superfoods)

Stomach problems – 13, children 38, Honeygar 98, 105, 107, 109 (see also **Motion sickness, Nausea, Digestive distress**)

Strains – 11, stiffness 112

Sunburn – 27, 39, 50 (see also **Skin ailments**)

T

Teething – 7

Toothache – 7

Tobacco smoke – 131

Tension – 25, 97, 111 (see also **Fatigue**)

Typhoid – 134

V

Viruses – GSE 14, salt 31, 34, Steri-Pen®, 101, Mini-Mate Air Supply™ 131 (see also **Antimicrobial, Bacteria, Flu-like symptoms, Infection**)

W

Water disinfection and preparation – see **Disinfect**

Wounds – 7, 11, 27 (see also **Antimicrobial, Bacteria, Disinfect, Infection**)

Windburn – 27 (see also **Skin ailments**)